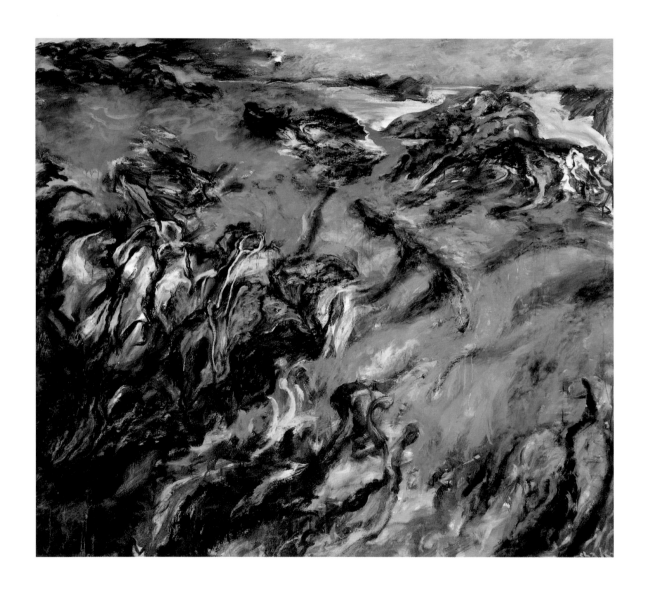

Chak 翟宗浩

Landscapes and Other
Natural Occurrences
山水與其他自然意象

香港大學美術博物館
University Museum and Art Gallery
The University of Hong Kong

Published for Chak's exhibition at
University Museum and Art Gallery,
The University of Hong Kong
7 February–3 May 2020

本書是香港大學美術博物館為配合
《翟宗浩：山水與其他自然意象》
專題展覽而編製，該展覽展期為
二零二零年二月七日至二零二零年
五月三日。

Cover: Beyond the Waterfall, 2019
封面：流向遠方的瀑布

Frontis: Enchanted Isles, 2019
扉頁：叫人着迷的島嶼

Translation and Editing by Wing Chan and Kikki Lam
翻譯與編輯：陳穎華、林嘉琪

First Edition 第一版
February 2020 二零二零年二月

© University Museum and Art Gallery,
The University of Hong Kong, 2020
© 香港大學美術博物館，二零二零年

ISBN 國際標準書號
978-988-19025-0-4

Organised by 主辦

香港大學美術博物館
University Museum and Art Gallery
The University of Hong Kong

Supported by 支持

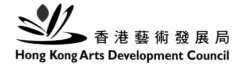

香港藝術發展局
Hong Kong Arts Development Council

Table of Contents 目錄

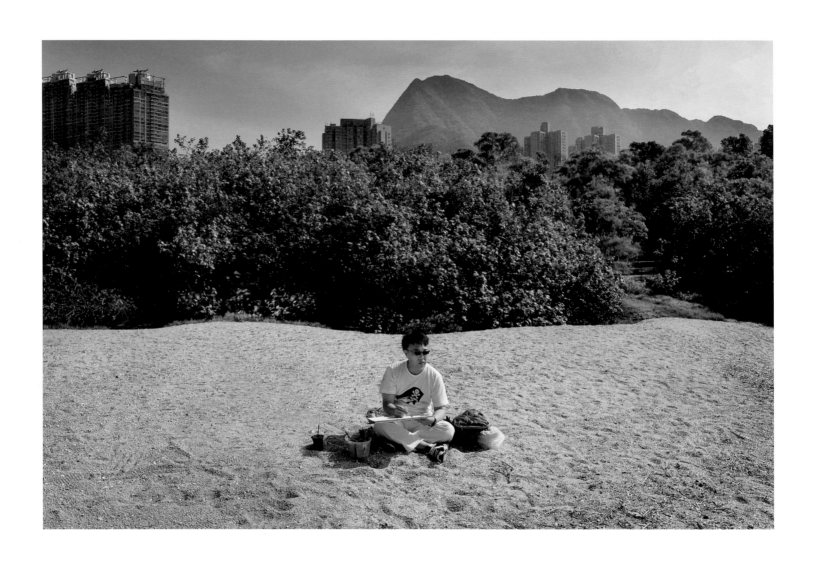

Chak drawing on the beach at Wu Kwai Sha

翟宗浩在烏溪沙沙灘上作畫

Foreword 前言

The University Museum and Art Gallery is delighted to be collaborating with the Hong Kong painter Chak on a display of his most recent artworks on canvas and paper.

Known primarily for his landscapes, Chak paints the forms of the natural world in abstract and poetic ways. After showing internationally—having lived in Japan and the USA for several decades—*Chak: Landscapes and Other Natural Occurrences* is one of the first significant solo exhibitions of the artist's work to be displayed in Hong Kong. The UMAG exhibition highlights both his larger two-panel canvases and smaller works on paper as a way to illustrate the artist's evolution of thought.

Solidly grounded in traditional methodologies, Chak's philosophy of painting is drawn out in oil, acrylic and ink. Each composition is a manifestation of the painter's belief in the need to remain in conversation with nature. His study of plants, rivers and hillsides are influenced by the painter's idealised mission to recreate nature through his own sophisticated form of craftsmanship. Chak is fascinated with the calm that nature offers each of us to recharge amidst our hectic days within urban environments.

We would like to thank Chak for this succesful collaboration, and to express our gratitude to the Hong Kong Arts Development Council for their financial support of the exhibition and publication.

—Dr Florian Knothe, Director, University Museum and Art Gallery, HKU

香港大學美術博物館很榮幸能夠與香港畫家翟宗浩合作，展出他近年創作的布本和紙本作品。

翟宗浩以山水畫見稱，他以抽象和富有詩意的方式描繪大自然的輪廓。繼在世界各地參展後——他曾居於日本和美國數十載——《翟宗浩：山水與其他自然意象》展覽是翟宗浩在港舉辦最重要的首個個展之一。是次展覽精選展示他的大型雙屏布本作品和尺寸較小的紙本作品，以呈現其思緒的演變。

翟宗浩的繪畫哲學紮根於傳統技法，他的油彩、塑膠彩和水墨作品處處流露着這種哲學思想。每件作品的構圖布局，皆體現這位畫家堅持其作品需與自然對話的信念。通過一己之精湛且成熟的繪畫技法來重塑自然，是翟宗浩的理想化抱負。這項使命於他對植物、河川和山坡的研究影響深遠。大自然那使人感到平靜安寧、以及為身處繁華鬧市且日無暇晷的人注入動力的能力，使翟宗浩為之著迷。

我們衷心感謝翟宗浩願與本館一同策劃展覽，取得豐碩成果。我們也感謝香港藝術發展局對本展覽和相關出版工作的贊助支持。

—香港大學美術博物館總監
羅諾德博士

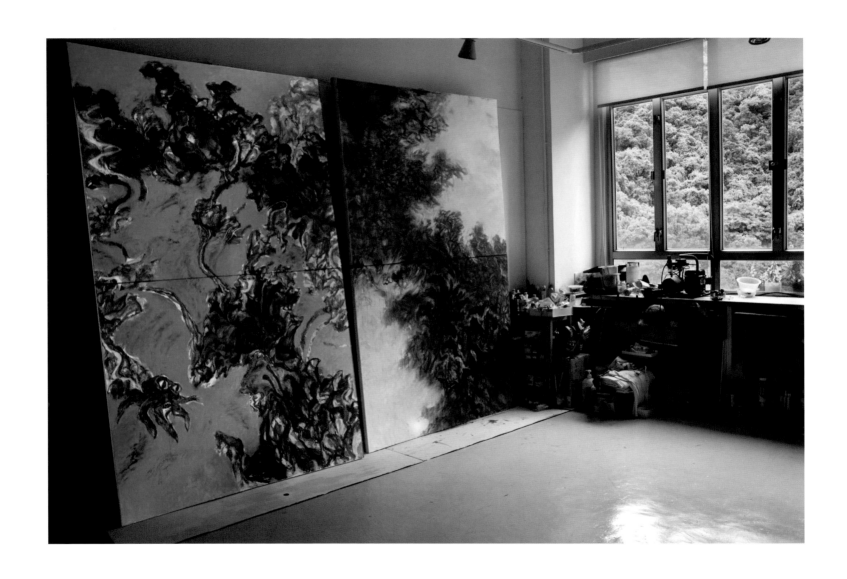

Chak's studio in Fo Tan
翟宗浩位於火炭的工作室

Creating Air: A Conversation with Chak

Chak graduated from the Department of Fine Arts at the Chinese University of Hong Kong in 1981, where he studied with the modernist master Liu Kuo-sung. With his students, Liu stressed the necessity of considering multiple artistic traditions and unconventional modes of brushwork as a way to transform Chinese painting. During his undergraduate years, Chak incorporated a broad range of contemporary theories and materials, for which he received many prestigious awards, including honours from the Contemporary Hong Kong Art Biennial (Hong Kong Museum of Art, 1979) and Youth Art Now: Asia (Hong Kong Arts Centre, 1980). After graduation, he was awarded a Monbusho Scholarship to continue his education at the Tokyo National University of Fine Arts. Chak then went on to study in the United States, completing an MA from Ball State University in 1986, an MFA from Queens College in New York, a residency at the Skowhegan School of Painting and Sculpture in Maine and the National Artists Program at the P.S.1 Contemporary Art Center in New York City. Throughout the 1980s and early '90s, Chak's work was shown widely in Hong Kong, New York, Tokyo and Taipei. After living abroad for nearly 30 years, he returned to Hong Kong in 2009. The following conversation took place at the artist's Fotan studio and at the University Museum and Art Gallery (UMAG) at HKU between October and early December 2019. The discussion between Chak and UMAG curator Christopher Mattison moves from the philosophical underpinnings of Chak's paintings—rooted both in Descartes and classical works like the *Zhuangzi*—to his experimentation with various mediums and types of brushwork, which combine to form the basis for his definition of 'Chinese Painting'. Over the decades, Chak has explored both contemporary and traditional elements in his landscapes, while considering the limits of human expression via the forms and colours of the natural world.

Christopher Mattison: You routinely emphasise the importance of the philosophical framework behind your art, and that a crucial layer of your creative practice is a variant of the Cartesian paradigm—one in which you swap out 'I think' for 'I paint'. Does this mean that you define yourself, at least in part, based on Descarte's explorations into the relationship between the mind and sensory experience?

Chak: Let me address your question with another philosopher—Martin Buber—who uses the natural world to explain the relationship between the linked terms of 'I-Thou' and 'I-It', which I find helpful when discussing my art. In Buber's line of reasoning, these pairs of terms do not signify any particular thing, but are meant to suggest the relationships between individuals ('I') and the broader world ('Thou' or 'It'). It is key to note these terms are not innately in contradiction, but due to conflicting viewpoints, the final results can differ. For example, when a forest is viewed as an isolated object (as an 'It'), the trees run the risk of being reduced to firewood or construction material. But when the forest is placed on equal footing with humanity, the natural world's ability to renew itself and to transform the human eye is similarly reinforced.

When an audience relegates a painting to coloured powder and linseed oil, the physical materials are no longer able to reach beyond their chemical foundations to something more profound. Perhaps it is most useful to consider the 'Cartesian paradigm' as an attitudinal shift in our various relationships. In Buber's words, "I become through my relations . . . All real living is meeting". My paintings are concerned with sensation as viewed through our relationships with the natural world. I think it is crucial to stress the metaphysical nature of my artwork, so that the gouache, oils and acrylics all become part of the transformation between mind and sensation.

CM: As you point out, in Buber's argument the natural world is considered an integral part of human experience; the forest is never reduced to a commodity. Such a focus on exploring and representing human sensation via these relationships, or 'meetings', with sensory experience does raise other issues when considering Descartes' suspicions about sensation as a basis for knowledge, but I understand the basic impulse to use the construct—"I paint therefore I am"—as a way to question your artistic practice. Referring back to your undergraduate training with Liu Kuo-sung, does your choice of materials also tie in with your understanding of being an artist?

Chak: Individual brushstrokes are merely pointers and physical markings of a 'Now'—the present moment, which serves as 'proof' that I am alive. When applying a dab of ultramarine to the canvas, it feels like I am actually creating air, which may culminate in me painting a sky over a horizon. The magic of this moment occurs right in front of my eyes, and through a form of actualisation—in this case brushstrokes—a specific instance is rendered into a frozen sign. Representing our own 'presence' on canvas is a considerably more complex act.

Gabriel Marcel's theory of 'Primary and Secondary Reflection' is similarly concerned with this same nebulous query of 'Who am I?'. As an artist, I often begin with Marcel's concept of 'Primary Reflection', which is composed of the stages of personal inspection, analysis and a visual deconstruction of one's physical surroundings. The following part of his theory, 'Secondary Reflection', continues with the stages of internalisation, reconstruction and a final rearrangement of the investigated elements. One could make an analogy to his theory and the phoenix's legendary series of reincarnations, and by and large the overall process does contain a sense of the mythical and a striving for divine perfection.

Bound up in such a dilemma, we can remain caught in the stage of introspection, along with Marcel, who wonders—is a farmer still a farmer when he leaves his land? Or a sailor when he's not at sea? The survival of the individual components of these pairs are inextricably linked, and it is impossible for me to say whether the individual brushstrokes, or the broader concepts behind the visual elements, are more or less vital to me as an artist. What I do 'know' is that I need to paint.

CM: In this equation, the brushstrokes, the element of craftsmanship, are integral to your analysis and representation of the natural world. What seems crucial here is the form of contemplation that you aspire to create for audiences, assuming that you do have a particular audience in mind.

Chak: To be honest, I never really consider an audience. My focus has always been on exploring and conversing with the trees and hills that are otherwise largely ignored. Painting for me has never involved an attempt to appease any third party, but instead to target a subject's essence, to recreate its 'being'. This is what seems most natural to me.

In terms of the actual brushstrokes, within some schools of contemporary art, skill and technique have become subordinate to conceptual gimmicks. This can be seen, in part, as a result of the Duchampian legacy that questions art's fundamental nature. Based on his revolutionary feat of manipulating the 'readymade' into a form of self-expression, we often forget Duchamp's foundational years as a highly accomplished Cubist painter. Numerous aspiring artists, influenced by his later innovations, have blindly stepped into the world under the false notion they can create meaningful work without an appropriate level of craftsmanship. This is problematic. To my understanding, practical competency is a basic requirement for any artist. The more skillful we become, the more easily and profoundly we can fulfil our desire to communicate. Artists who deal in shallow forms of visual language will quite naturally convey shallow ideas.

CM: In terms of artistic practice and competency, could you speak a bit more about your specific process and materials?

Chak: My daily routine is not particularly interesting. I usually get up early, eat breakfast, spend a couple hours reading, go for a walk and then take care of chores. I work on my paintings in the afternoon light, and in the evening I concentrate on unfinished sketches and set out a plan for the next day.

As for materials, over the last year I have been using acrylics to create a type of Chinese ink wash as a hazy background. There is an inherent fluidity to acrylics that proves useful when creating this effect. As an art student in the late 1970s, I was intrigued by the wave of Photorealism in the American art scene. In response to this, I spent several years trying to incorporate airbrush work and acrylics into my more traditional oil paints. I gave up on these experiments relatively quickly as I found the acrylics and airbrushed paints expressively lacking, and my heavier brushstrokes often collapsed as they dried. Forty years later, I now have a better grasp of the control needed, and I have begun to experiment with the water-soluble nature of acrylics as a way to layer and complement the oils.

CM: In one of our preliminary conversations you mentioned struggling with getting the acrylic paint to 'pop'—that it doesn't shimmer like oil. Could we examine one of the more recent works where you use both oils and acrylics? I am also curious about how the 'hazy background' relates to the remainder of the canvas.

Chak: *Early Spring* is a good example. Traditional Chinese painting uses a limited set of inks that are naturally more agile than oils. De Kooning, the master of Abstract Expressionism, used safflower rather than linseed oil because it dries more slowly, allowing him a longer amount of time to work on each canvas. I use water-soluble acrylics in a similar manner to create a splashed-ink effect. I could also add turpentine and linseed to my oils, but I believe the end results of those combinations are a bit thin and not nearly as striking.

CM: But within the paintings, what is the actual intent of the layer you refer to as a 'hazy background', and does this relate to how you sometimes start by building up areas of white in the centre image. There is a point, often in the middle or lower third of your work, where the movement of the brushstrokes is constricted and then surges ahead. I'm thinking of the drawing *Brotherhood of Streams* or the two-panel painting *Mountain Chorus*. These strictures, where the brushstrokes and waters are roiling around an object, could be either an origin point or a moment of erasure.

Chak: People have both passive and active aspects. When we view art, we are often limited by the images depicted by an artist, while we also can actively generate new reveries out of the visual stimulation. As far as the layers of white, and the blue used for the ocean and sky, one literal interpretation of the image is certainly of the natural world surging through Hong Kong, but these swatches of colour are also closely related to the prescribed compositions emphasised in Western formalism and the traditional blankness sometimes found in Chinese painting. A common theme in this and many of my works is the static versus the kinetic world. As the proverb states, "The trees long for peace but the wind will never cease."

Within any moment of calm, it is possible to feel an invisible force moving. The whiteness is used to represent another key opposition in my works—'scattering/gathering'—which is highlighted by the condensed movement of the strokes.

CM: For most of your life you have lived in hyper-urban settings—Hong Kong, Tokyo and New York City—but your paintings and drawings are concerned exclusively with layers of the natural world, and you seem uninspired by the palimpsests of urban structures. For example, over the past few years the view outside your studio window has been altered by the encroachment of a massive new housing complex, but your focus has remained squarely on the trees and their movements, their specific interplay of light and shadow against the hills.

Chak: Cities are, by definition, full of people. Every day we encounter thousands of individuals in a seemingly interconnected network, while unwittingly taking part in a complex process of alienation and estrangement. Our unconscious identifies each of these people as moving objects and most of these 'objects', in return, classify us just as indifferently and anonymously. Such a movement towards dehumanisation and objectification has become the basis for our relationships with much of the world. Within all of these highly compact and complex urban environments, we face the very modern issue of not always having the physical or mental capacity to efficiently maneuver and adapt to the expanding stimuli. We are literally suffocating in concrete and steel.

But within the realm of the natural world, such turmoil and trepidation completely disappears, at least for me. We climb hills to decompress. Trees lean against each other in solidarity and offer shade. Shadows rippling in the wind amplify rather than obstruct the setting sun. One might regard our relation-

ship to nature's physical elements as unidirectional, but the natural world has its own way of communicating. It embraces humanity and provides each of us a space for contemplation.

CM: Earlier you mentioned the need to 'communicate' and you have raised the point here again in relation to nature. One of the things I find most intriguing about the theoretical basis of your work is your awareness of the limitations of both text-based and visual languages. You seek to capture the imperceptible layers of sensation without idealising your own practice.

Chak: That's me channelling Wittgenstein on the limits of language! I view the cityscape as a fabricated structure with its own rigorous logic and set of rules, and I am inherently uninterested in such artificial constructs. In opposition to this, the natural world provides me the freedom to explore sensation and human experience through purely visual and 'natural' elements—an endless palette of forms, lines, shapes, compositions and hues. No matter how abstract the final outcomes, my representations of nature are inseparable from the physical trees, rocks and coastline. On canvas, the various elements (shapes and shadows) are allowed to ferment and expand into various states.

Perhaps because of their essence, rivers and the wind are often used to signify nature's immense power. And within life there are moments of surging forward, sudden retreats and then silence. This recurring loop of movement and stillness is the metaphysical basis for my work, as well as how I approach daily life and my understanding of the infinite. Dust from the stars will eventually fade, and the layer of 'culture' created by a writer or painter is really nothing more than a cosmic blip in a world that will continue to evolve long after humanity's presence has faded.

Returning briefly to Wittgenstein, his explorations of the ultimate limits of language reminds me of the tale in the *Zhuangzi*, where the fish Kun and bird Peng are used to express the vastness of the natural world. In the story, Kun is so many thousands of miles long that no one is able to measure its length, and when Kun transforms into the bird Peng, its back is so broad that again it is impossible to gauge. What excites me most about this metaphor is the immanent energy—that Peng can fly hundreds or thousands of miles with just a single flap of its wings. In short, humanity's impact is limited, while the natural world's ability to express itself is infinite.

創造空氣：與翟宗浩對話

翟宗浩一九八一年畢業於香港中文大學藝術系，師從現代水墨先驅劉國松，劉氏以改革中國書畫為己任，對學生影響深遠。莘莘學子在本科期間醉心當代文化理論，嘗試融會各方思潮與物料從事創作，屢獲殊譽，此中包括「當代香港藝術雙年展」油畫獎(香港藝術館，一九七九年)及「年輕藝術家：亞洲區」推薦獎(香港藝術中心，一九八零年)等等。畢業後獲日本政府文部省獎學金負笈東京藝術大學(油畫科第四研究室)，繼而赴美國繼續研修，先後在一九八六年獲印第安納州鮑爾州立大學碩士及紐約市立大學皇后書院藝術碩士學位，成績斐然，經皇后書院基金會舉薦，保送緬因州斯考基幹繪畫雕塑學院深造，次年入選紐約PS1當代美術館的國家藝術家駐留計劃。

從一九八零年至一九九零年代，翟宗浩的作品在香港、紐約、東京和台北廣泛展出，經過接近三十載旅居海外的歲月，翟宗浩於二零零九年末返回香港。下文摘錄自二零一九年十月至十二月初，香港大學美術博物館館長馬德松與畫家在藝術家的火炭工作室、以及香港大學美術博物館進行的對話。二人從創作之哲理基礎，如何根植西方形而上學，復遊刃本國老莊等經典，談到諸種媒介、繪畫要素和筆法實踐，點滴累積，建構出他所理解未來「中國山水畫」之路向。同時畫家就大自然現象、色彩和風貌多方鑽研解讀，仔細推敲人類表情達意之極限。

馬德松：你一直堅持作品背後的哲學思維，舉足輕重，選擇笛卡兒作為立足起點，針對命題「我思故我在」提出申辯，以「我畫」取締「我思」。這是否意味着你的創作，是據笛卡兒對思想與觸感經驗關係之探索來發展？

翟宗浩：容我援引另一位哲學家馬丁·畢柏來回答你的提問。畢柏以自然界去闡釋「我與你」和「我與它」這兩組詞彙的關係，上述的概念有助理解我的藝術。在論證過程中，「我、你、它」並不一定指向某特定事或物，旨在凸顯個人(「我」)與更廣闊外界／ 世界(「你」和「它」)的互動；故此，上述三者並非矛盾的觀念，而是鑑於觀點立場分歧，結論自然廻異。例如當森林被歸類為孤立的個體(「它」)，樹木便冒上遭砍伐成柴薪或僱作建築材料的風險；假若人們(「我」)視生機旺盛的植物與人類對等，兩者平起平坐，自然界立刻擁有更張和優化人類(「你」)視野的能力。

同一道理，當觀眾將畫作界定為純粹的顏色粉末和亞蔴籽油，作品肯定不足以超越物質和化學規限，無法更上層樓。因此我們必須就笛卡兒思想作出解讀上的挪移，才可事半功倍，恰如畢柏的說辭：「與外界衍生關係讓我得以成立……舉凡真實的人生皆緣自(跟別人之)相遇」，我的畫作建基於人與自然的感性交往，當中因涉及形而上的精神探索，令水粉、油彩等物質成為思想與感性之間的轉化的載體。

馬德松：如你所述，畢柏認為自然界是人類經驗不可或缺的一部分，樹木永遠都不可能只是一種商品。將笛卡兒之於「感官作為知識基礎的存疑」的概念，與你通過各種關係或「偶遇」、並感官經驗來探索和表達人類的情感的手法一同理解，的確發人深省。但我認為你是通過「我畫故我在」的理念，挑戰一己之藝術實踐。回顧你師承劉國松的本科訓練，當時你所揀選用作表達之媒介，是否與你對何謂藝術家的理解互相呼應？

翟宗浩：筆觸其實是「當下」的指標和物理印記，「證明」人仍然活着。當我往畫布塗上一抹群青，油然感覺自己正在創造空氣，甚至仿佛身處地平線邊沿，正在描繪一片天空。剎那間這種魔力湧現眼前，它通過顏料浮現，讓此刻凝固成永恆⋯⋯當然如何以畫布鎪刻「存在」的奧妙，是一門複雜的學問。

論到「我是誰」這含糊的疑慮，非一提加百列・馬塞爾的「第一和第二反思」不可。作為一位藝術家，我在落筆之先大多遵循他的「第一反思」，即由個人檢視、分析和視覺上解構周遭環境作切入，然後再進入較深層次的「第二反思」，乃內化、重構等工序。「第一反思」應允我們搜羅各式相關議題，集腋成裘，再改投「第二反思」重新給予安排。大家不妨將馬塞爾的理論喻作火浴鳳凰之轉世，此過程包含了神話般的再生，以及對神聖完美的訴求。

問題來了，置身這兩難（神話再造和完美追逐同樣得來不易）底下，人們胝足「第二反思」的門檻，往往會感覺失落無助，忐忑不安，不過馬塞爾慷慨，無私地提出解厄的竅訣：農夫離開了土地還能稱得上耕戶嗎？或是當水手離開驚濤駭浪的汪洋，他仍是水手嗎？上述第二反思的幻化及提升牽涉社會脈絡，千絲萬縷，憑誰也無法疏濬清楚，恰好跟我沒能解釋：相對於表面的皴染勾勒，背後各式視覺元素及理論有似盤根般糾纏，如何令物質昇華，作品怎樣反映始作蛹者的人格，大量謎團委實難以言全。唯一能夠明辨的，要數這麼一撇油彩我的確非落筆不可！

馬德松：如此一來，筆觸和技巧是你分析和呈現自然的一部分。談到這裏，似乎你渴望為觀眾而創作（我假設你腦海中已具備特定的觀眾）的思考方式，是至關重要的。

翟宗浩：坦白而言，我一直只知專注訪尋林木和山岳的精靈，與之對話，沉默中它們常常被大家忽略，至於觀眾這事兒倒未曾好好考慮。繪畫之於我不在乎安撫或取悅，僅渴望能參透描寫對象，重現其「存有」及真相，這目標似乎最具挑戰，亦自然不過！

一旦涉足技法材料，矛頭勢將直指當代藝術，其中多少流派視技藝如糟粕，一昧地專崇概念先行。某程度上，這種風氣承傳自杜象對藝文本質之存疑。他將「現成物」轉化特立獨行的自我表現，可惜追捧者總忘卻大師年輕時已是一位傑出的立體派畫家，手藝卓絕。這些追隨者受到杜象後期創作概念左右，多肩負錯誤觀念、盲目闖關，以為無需紮根功夫依舊可以平地一聲雷，炮製出驚世傑作。依我的愚見，造詣是任何創新之基礎，偉大文學家、作曲家、科學家總不會整天假手他人⋯⋯技藝思維愈洗練，便愈能夠深邃地體現作家渴望的溝通，才華闕如的二流子勉強掌握過單薄的視覺語言，自然只曉得重複膚淺的空中樓閣。

馬德松：就藝術實踐方面，你可否分享一下物料處理和創作過程？

翟宗浩：我的日常生活並不特別生動精采。我通常清晨起床，先讀書兩個小時，吃過早飯後也許散散步，或者處理瑣事雜務。待至午後陽光充沛便動手描繪，晚上則專注未完成的素描，替明天稍作計劃。

　　至於素材方面，我去年開始起用塑膠彩給油畫打草稿，塑膠彩本身充滿了流動性，適合呈現朦朧背景的墨染質感。一九七零年代末期，當時仍是藝術學生的我，對美國畫壇的照相寫實主義頗覺着迷。我為此奉獻了兩年光陰，企圖假借噴槍和畫筆把塑膠彩納為己用，可惜沒多久便主動放棄，因為我發現這顏料缺乏張力，尤其在厚重勾劃底下，水份揮發後原先的紋理及痕跡會無端塌陷，乃至消失。事隔四十年的今天，始明白取長補短的道理，重新採用塑膠彩的水溶動感，鋪陳預設效果，再往上揩抹油彩，讓二者相得益彰。

馬德松：剛才我們提到以塑膠彩塑形的困擾，即它欠缺油彩那豐富的層次。現可就你最近以塑膠彩和油彩創作的作品加以分析討論嗎？我也想了解你所謂的「朦朧背景」，它與畫面其他局部的關係。

翟宗浩：《早春》是個頗為貼切的例子…… 傳統中國水墨畫雖受制於黑白灰等色階，卻先天性較油彩流暢靈活。抽象表現主義大師德·庫寧以紅花籽油替代亞麻籽油創作，因為前者的風乾期較長，讓他能有更充裕時間去刪改和修繕。換言之，藝術家應當專業，懂得和善用物料特質，譬如擷取塑膠彩的水溶特性，往蔴布塑造出潑墨效果；當然給油彩灌注大量松節水和亞麻籽油亦無不可，可惜稀釋總令顏色見得薄弱，成為另一漂染章回，無法達至相同魅力。

馬德松：你繪畫作品中的「朦朧背景」有何深意？就明暗分布而言，它與畫面置中位置的飛白有何關係？此外，你的作品中下方的色塊筆觸往往徘徊不前，側筆繼而湧現，譬如素描《小溪與河流的滙流》和二聯畫《山嶺之謳歌》，寬敞色塊環繞山石徐徐展開，這麼一來它既是落筆起點，同時又是塗抹景物的瞬間。

翟宗浩：這可是一石二鳥的技倆，試想一回，觀者的角色既被動也主動，人們細看畫作，必然深受其鼓舞、影響和規限，亦因應提供的視覺刺激衍生出嶄新想像。觀眾凝視圖中的海岸或綿綿春霧，輕易就能聯想到香港的地誌風貌。與此同時，這些色塊與線條分割跟西方形式主義的抽象構圖、以及國畫傳統「留白」關係密切。有所謂樹欲靜而風不息，我的畫作不乏「動／靜」對比等烘托手法，刻意就畫面穿插一刻寧靜，讓無形慄動潛藏伏匿，待機而發。這些虛白也維繫着另一條預設，即畫面不同視覺元素之「聚／散」，影射人生的陰晴圓缺，在「靜」與「散」驅策下，筆勢蘊含的動態威力方可施展抱負。

馬德松：一直以來你寓居高密度的城市，譬如香港、東京和紐約，然而畫作卻熱中捕捉自然界的各個層面，總不為城市景觀所動。這些年，你火炭工作室窗外風物早因大規模的公共房屋興建項目而面目全非。然而，你作品的注意力始終聚焦於荒郊野嶺，汲取丘壑中樹木搖曳的光影。

翟宗浩：城市本來就充塞着群眾，人們每天都會遇上千百計陌路過客，卻永遠看不清個別臉孔。我們不知不覺間已參與了當中的疏離，潛意識勉勵大家漠視彼此，把旁人釐定為流動的「東西」，理所當然地這些「流動的東西」同樣冷酷地看待我們。這種去人性和物化行徑早榮登「灰色叢林」不成文定律榜首；躋身高度密集的大都會，我們盡享摩登帶來的方便，也瀕臨眾多惡果，無時無刻不在應付科技挑釁，全方位精神刺激等進襲叫人筋疲力歇，苟延殘喘的你和我俯伏在混凝土和鋼根的壓抑下，奄奄一息。

然而輾轉回歸大自然，上述的動盪與不安驟然消停。人們登高減壓，但看林木互相靠攏，樹影婆娑，於夕陽晚照中彼此庇蔭。也許大家會誤信人與自然的溝通純屬線性單向，實際上天與地每每以無形的恢宏跟我們交滙，它擁簇人類，並且給予我們沉澱的空間。

馬德松：前文提及「溝通」之必要，此處你再次討論作品中「人與自然互動」的議題……我認為你對於以文本為基礎的視覺語言之限制的關注，是你的創作理論中最引人入勝的地方。你也能在避免創作過分理想化的情況下，捕捉到那難以明察的感官體驗。

翟宗浩：這題目正正是維根斯坦提出「語言極限亦即我們世界之盡頭」的引申！城市景觀無疑具備自身嚴格的邏輯和章程，可惜這些人工結構一直與我不投緣，反之大自然給予各種原始條件，即無數未加綴飾的曲線、形狀、模樣、架構及色調，允許人們探秘尋幽，自由自在。無論圖畫最後有多抽象，我關心的事物跟山巖、花鳥和海岸密不可分，畫布上諸種要素多能夠拚勁發酵，開拓出千態萬狀的美。

或許是本質驅使，山川灝氣總愛呈現自然巨大的能量，它們流動時或洶湧澎湃，力拔山河，忽又沈吟不語，隱退緘默；這一靜一動的循環，恰好成為作品中精神基石，春去秋來的輪廻，生生不息，赫然是我對永恆的理解……命運彷彿星塵，稍蹤即逝，作家窮一生創造，努力將身心和環境凝聚攝錄，到頭來亦不過雁過留痕罷了。

讓我們回到維根斯坦的討論。他就語言極限的倡導叫人蕭然起敬，不期然讓我憶起《逍遙遊》中片語，莊子以鯤魚與鵬鳥闡述萬化的寥廓雄偉，故事提到「鯤之大，不知其幾千里也。化而為鳥，其名為鵬。鵬之背，不知其幾千里也；怒而飛，其翼若垂天之雲」。句子教人振奮地方是它描寫日月星辰的膂力，鵬鳥只需揮擊翅膀即能飛掠萬千里。說得透徹，人類之於永恆，理解十分有限，等同繪畫的盡頭早屆文明訊息傳遞之極限，每念及此方知大自然橫無際涯，真箇奧秘。

The majority of works presented in this catalogue were created between 2018–19. All of the paintings are oil and acrylic on canvas, while the drawings are watercolour, gouache and ink on paper.

本圖錄所載翟宗浩的大部分作品，屬畫家於二零一八年至二零一九年間的創作。繪畫是油彩和塑膠彩布本，繪圖則是水彩、水粉和水墨紙本。

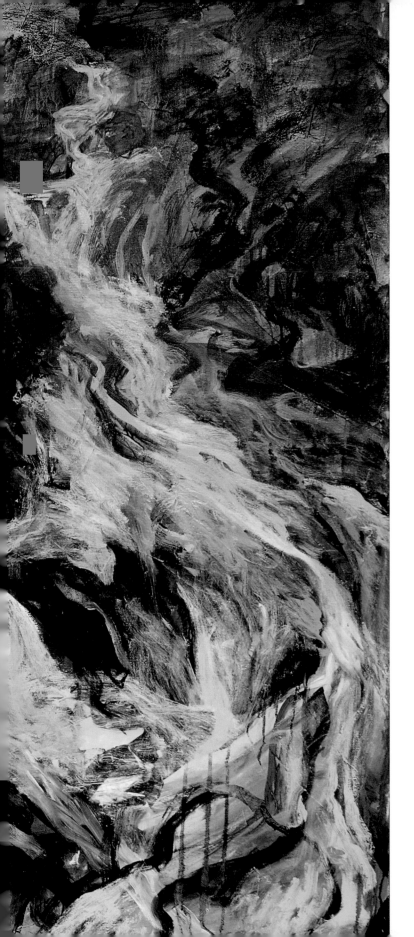

繪畫 Paintings

Brotherhood of Streams
小溪與河流的滙流
125.7 x 180.3 cm｜2018

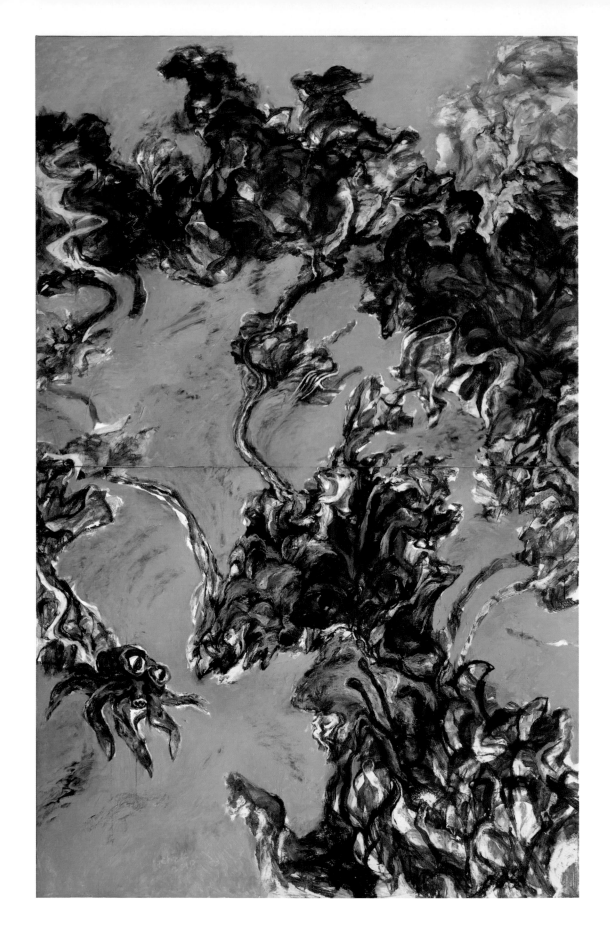

Kowloon + Hong Kong
Greeting Little Tako
香港 + 九龍跟小章魚的偶遇
243.8 x 152.4 cm | 2018

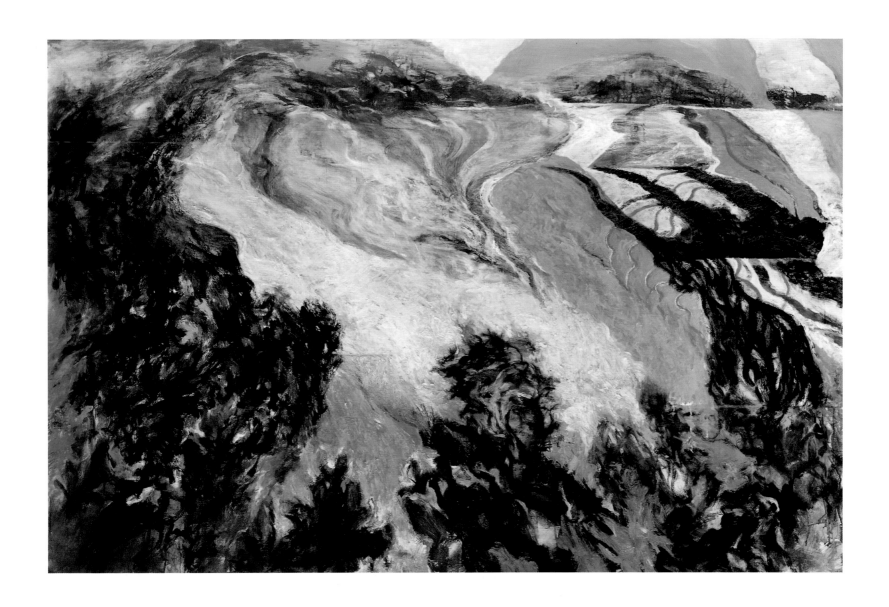

Elegy for the Yellow River
黃河東逝之哀歌
121.9 x 182.8 cm │ 2018–19

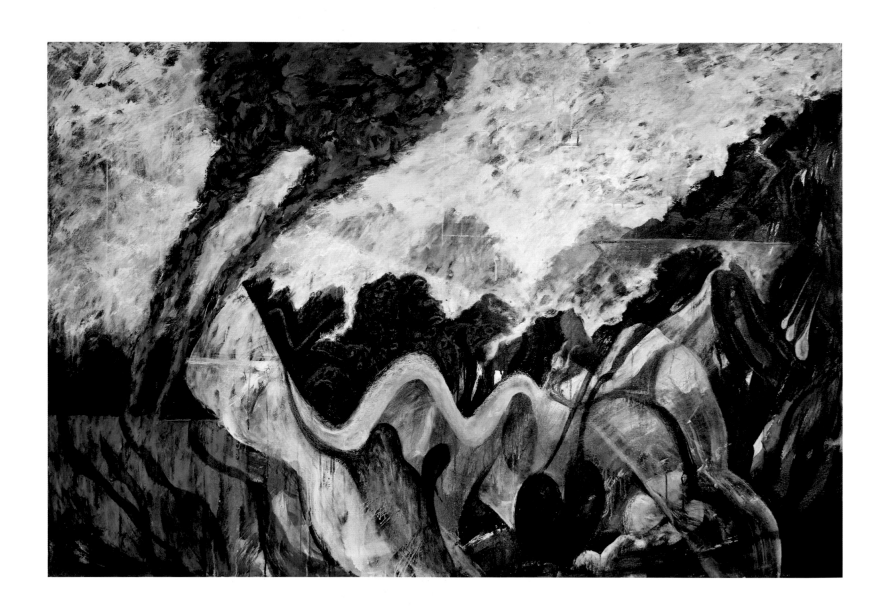

Lonesome Little Tako
寂寞的小章魚
121.9 x 182.8 cm │ 2012

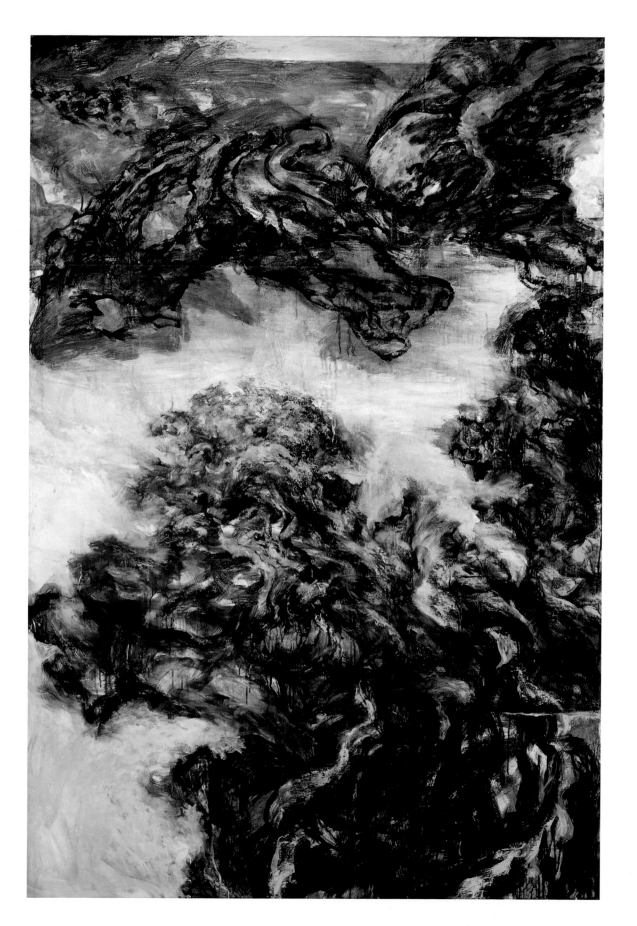

Wild April Revolution
四月的野生革命
182.8 x 121.9 cm | 2018

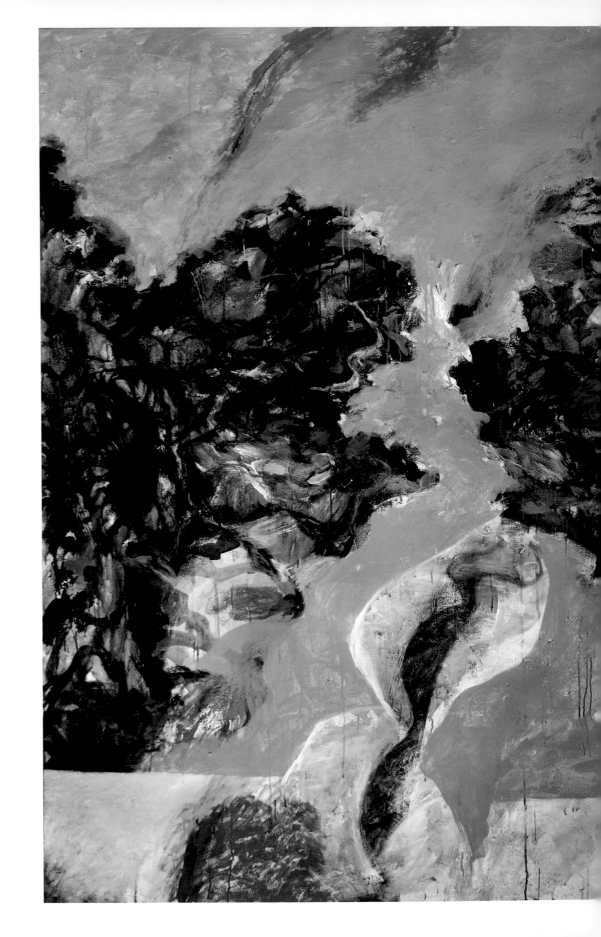

Peninsular
半島地區
182.8 x 243.8 cm | 2019

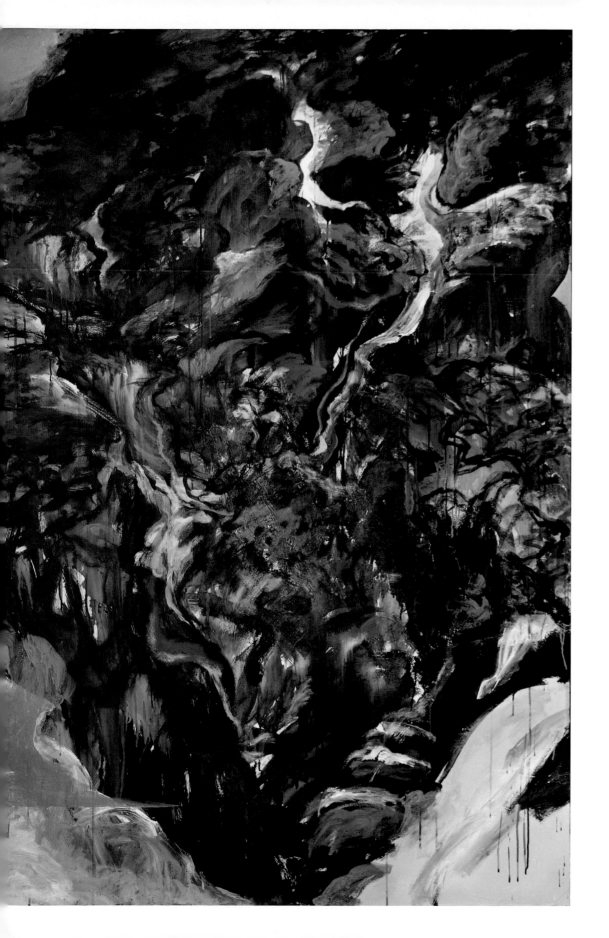

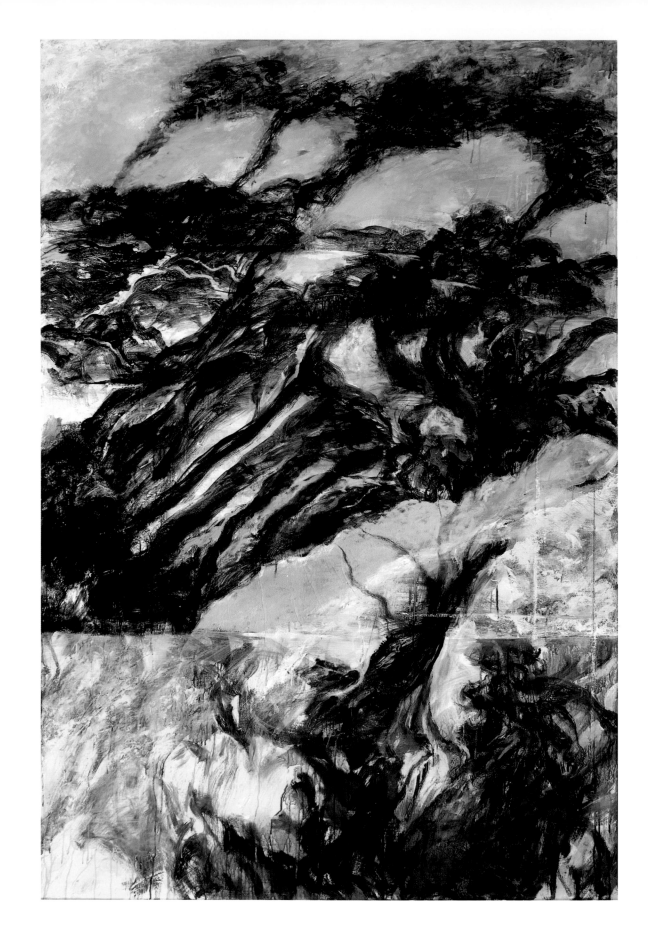

Early Spring
早春

182.8 x 121.9 cm │ 2019

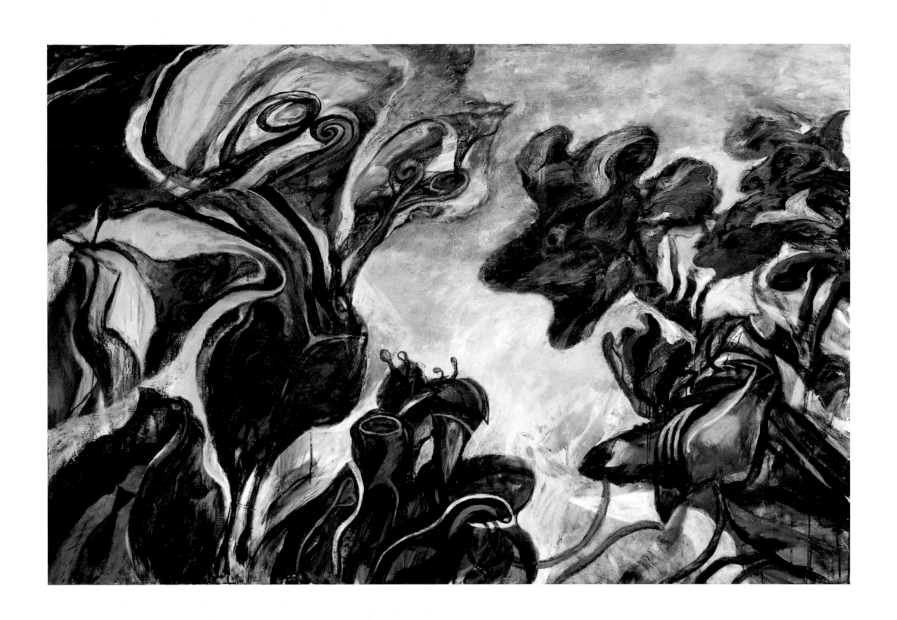

Flower-eating Fox
愛吃花朵的狐狸
121.9 x 182.8 cm │ 2018–19

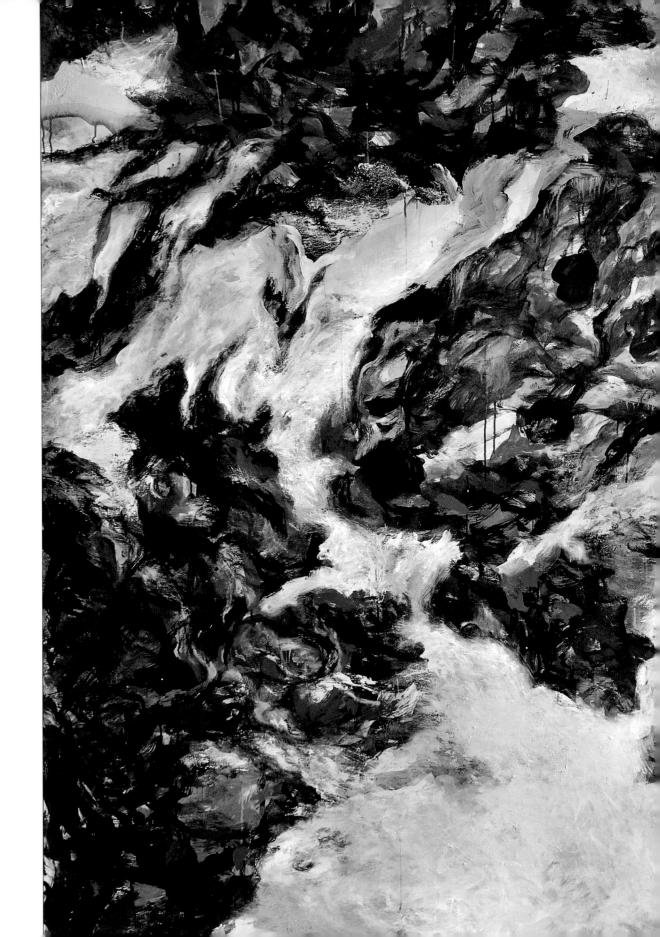

Mountain Chorus
山嶺之謳歌
182.8 x 243.8 cm │ 2019

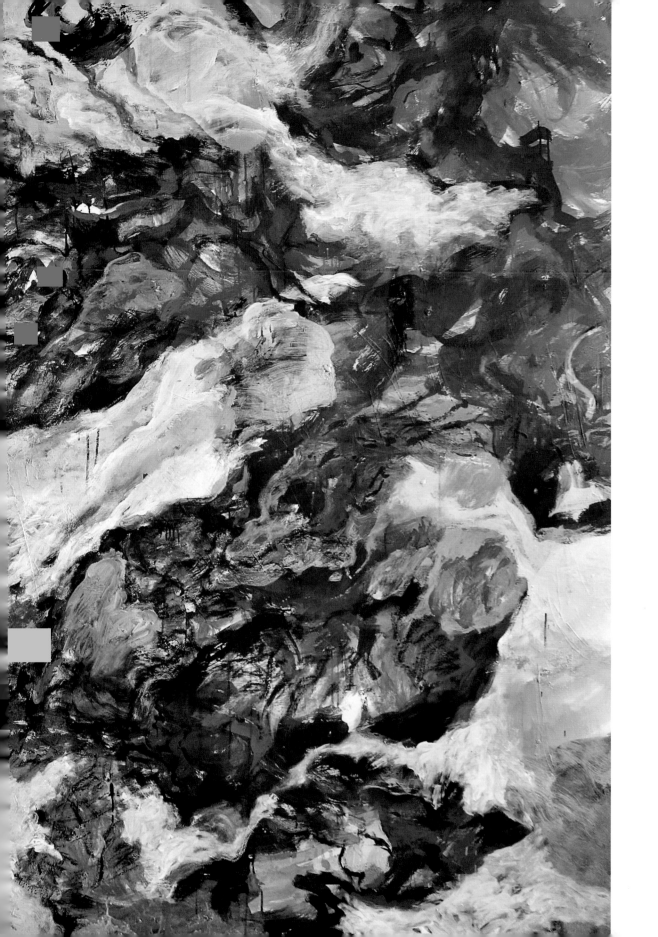

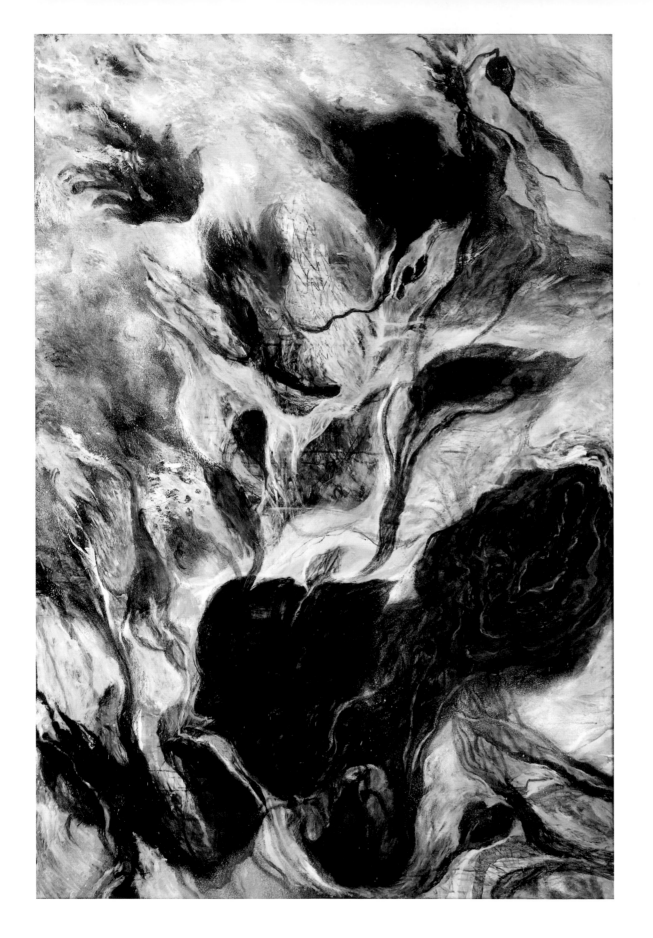

Spring Spark
早春的火花
182.8 x 121.9 cm │ 2018–19

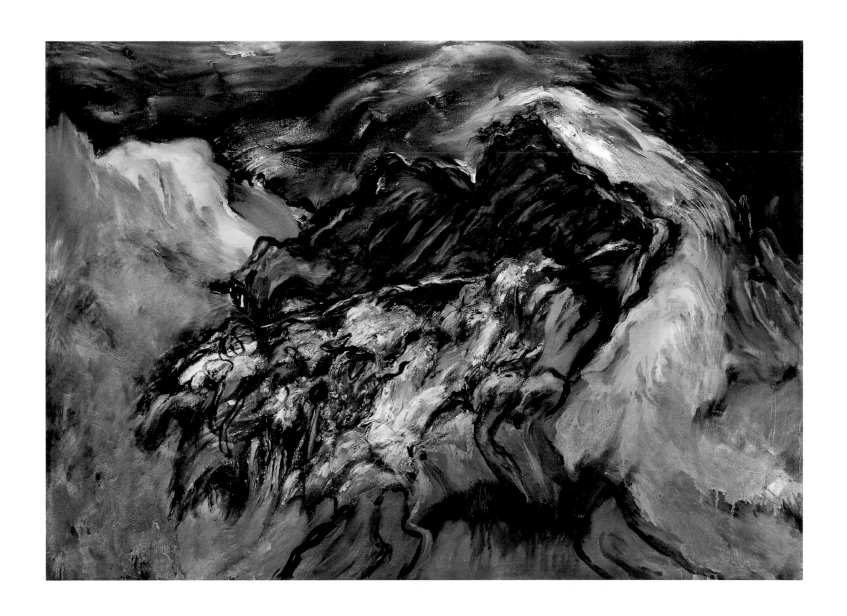

The Tempest
暴風雨
33.5 x 47.5 cm | 2013

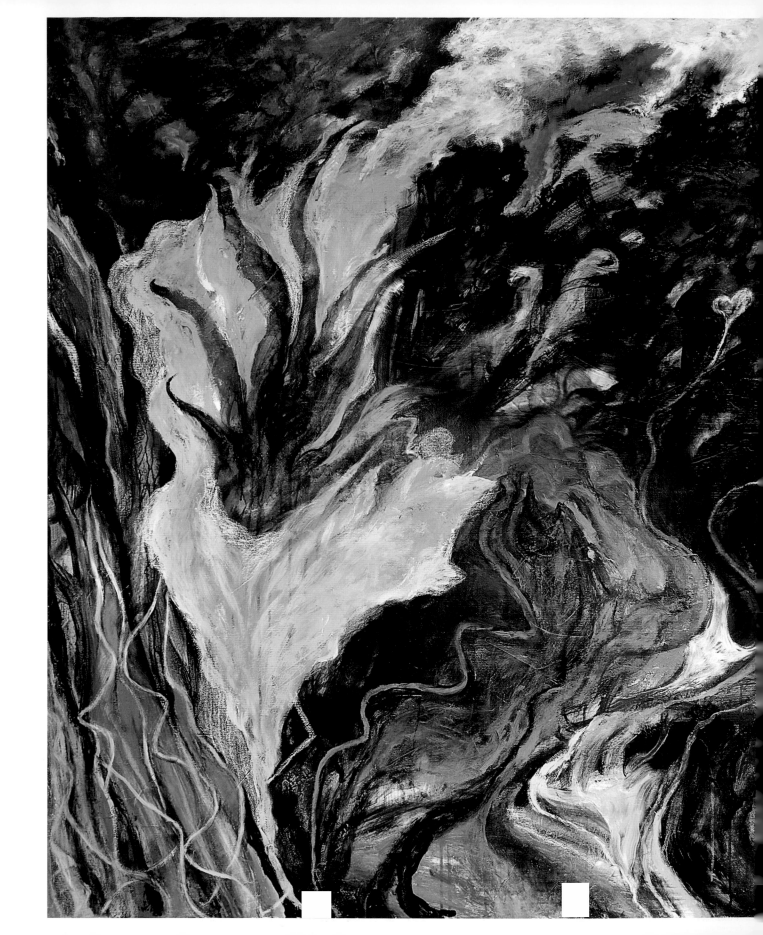

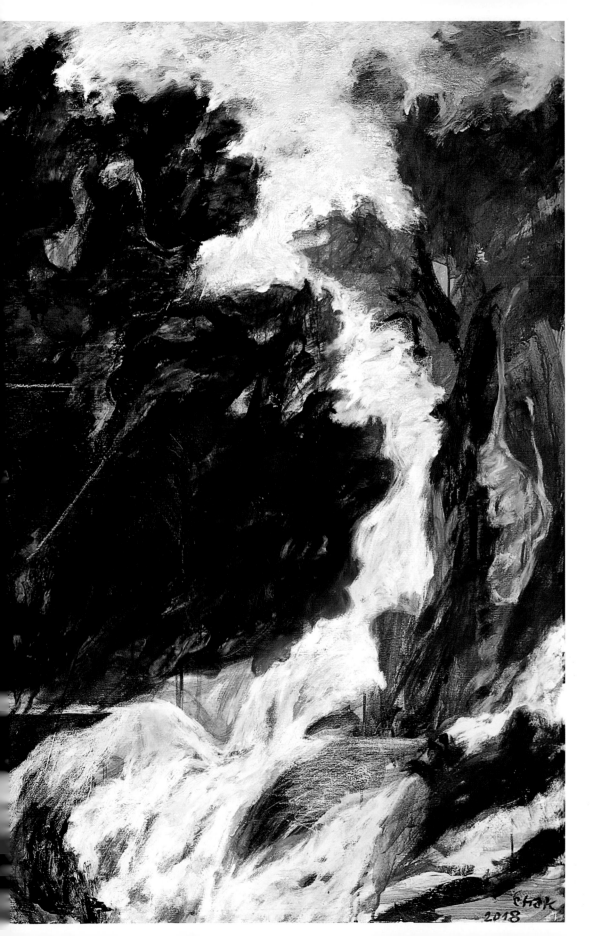

Lonesome Unfaithful Tako
花心又寂寞的章魚
125.7 x 180.3 cm | 2018

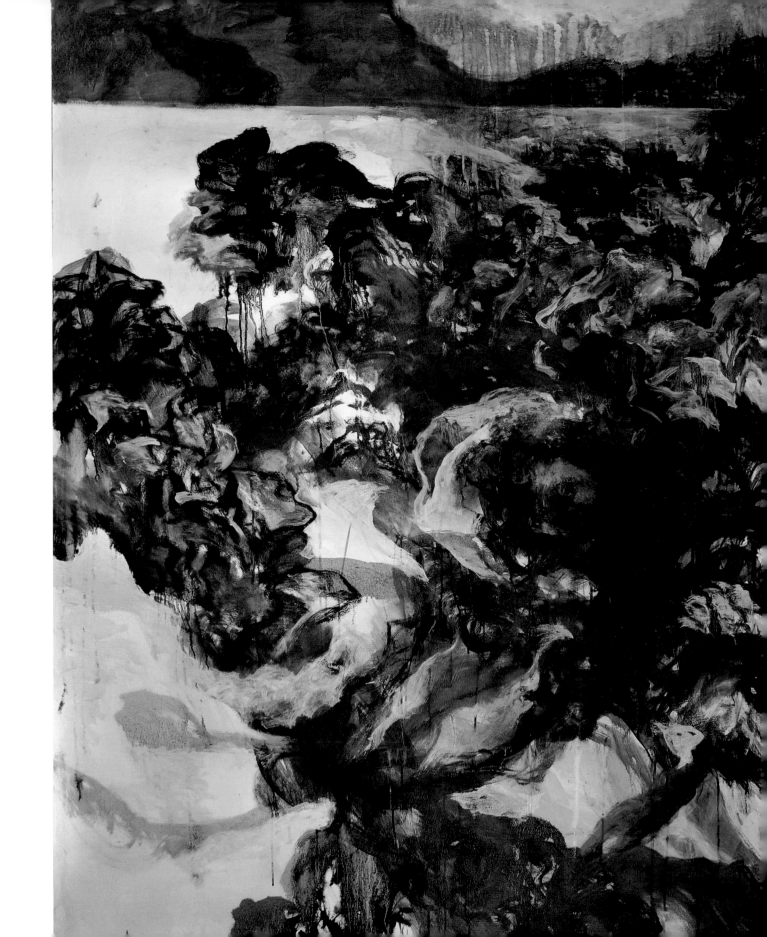

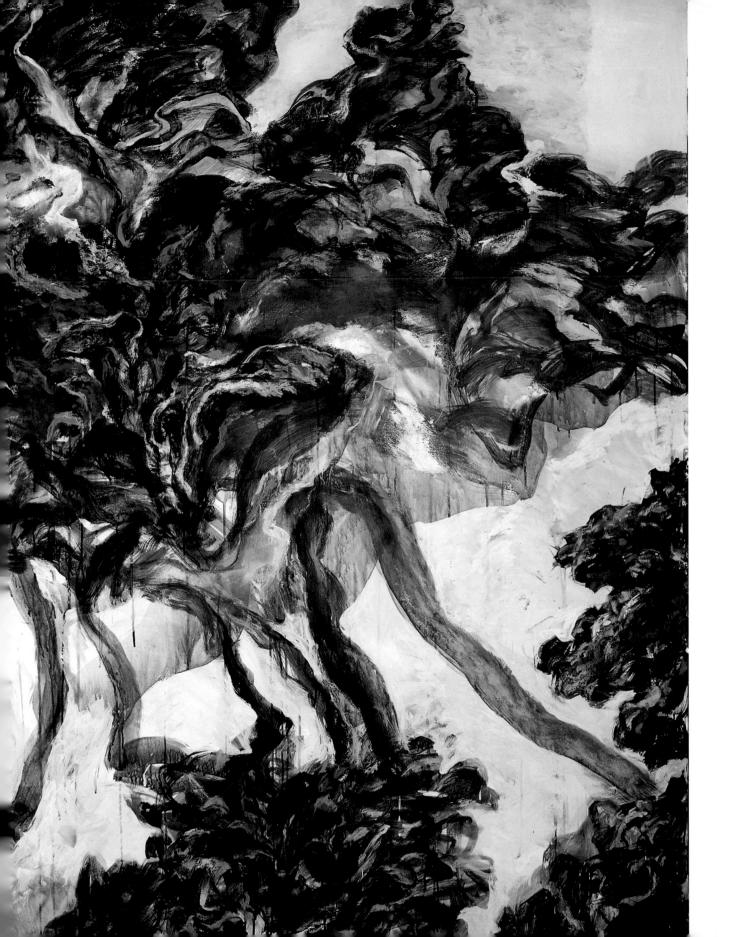

A Wedding:
One Country Two Lands
一國兩地的婚禮
182.8 x 275.5 cm | 2019

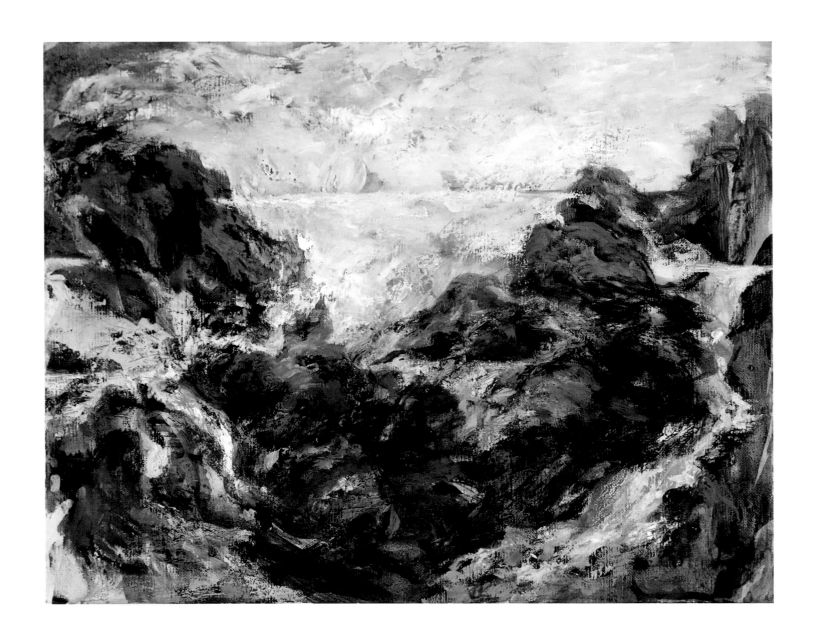

Gold Coast
黃金海岸
31.7 x 40.6 cm │ 2019

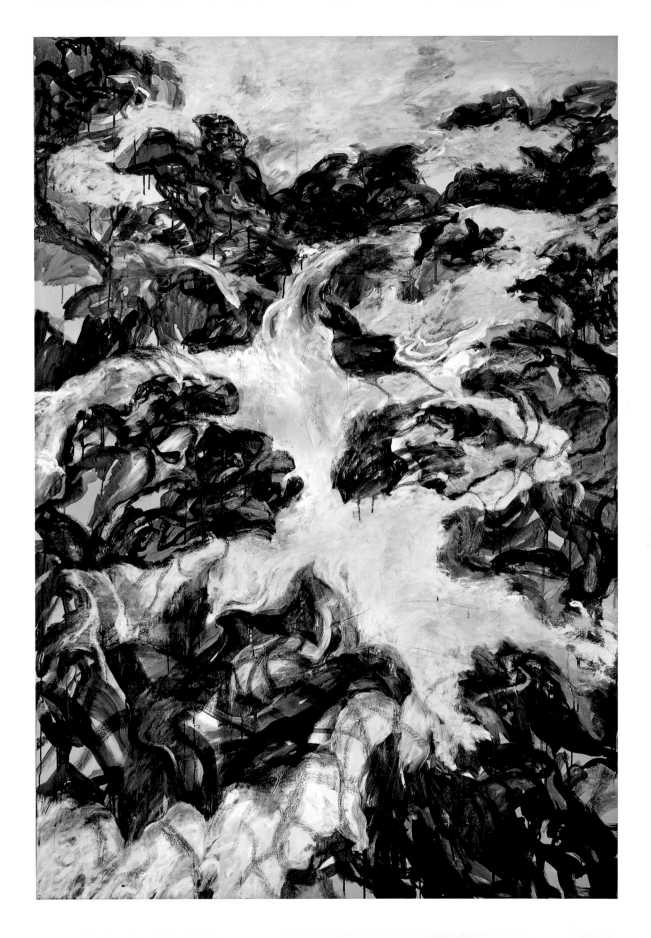

Mocking Bird Screaming
from Amah Rock
牠站在望夫石上高聲吶喊
182.8 x 121.9 cm │ 2019

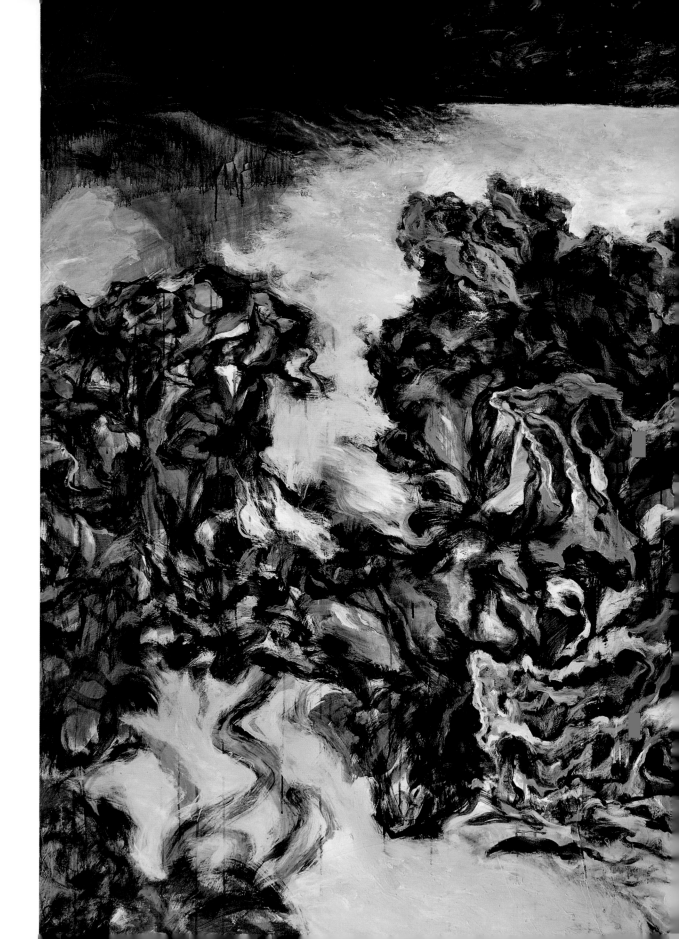

The Big Blue
海天一色
182.8 x 243.8 cm｜2019

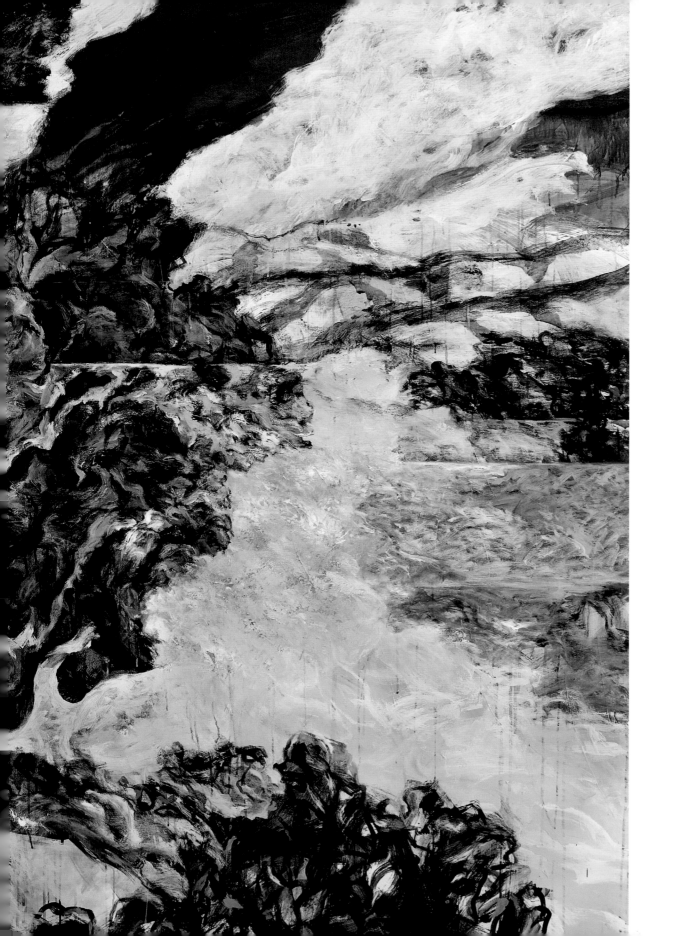

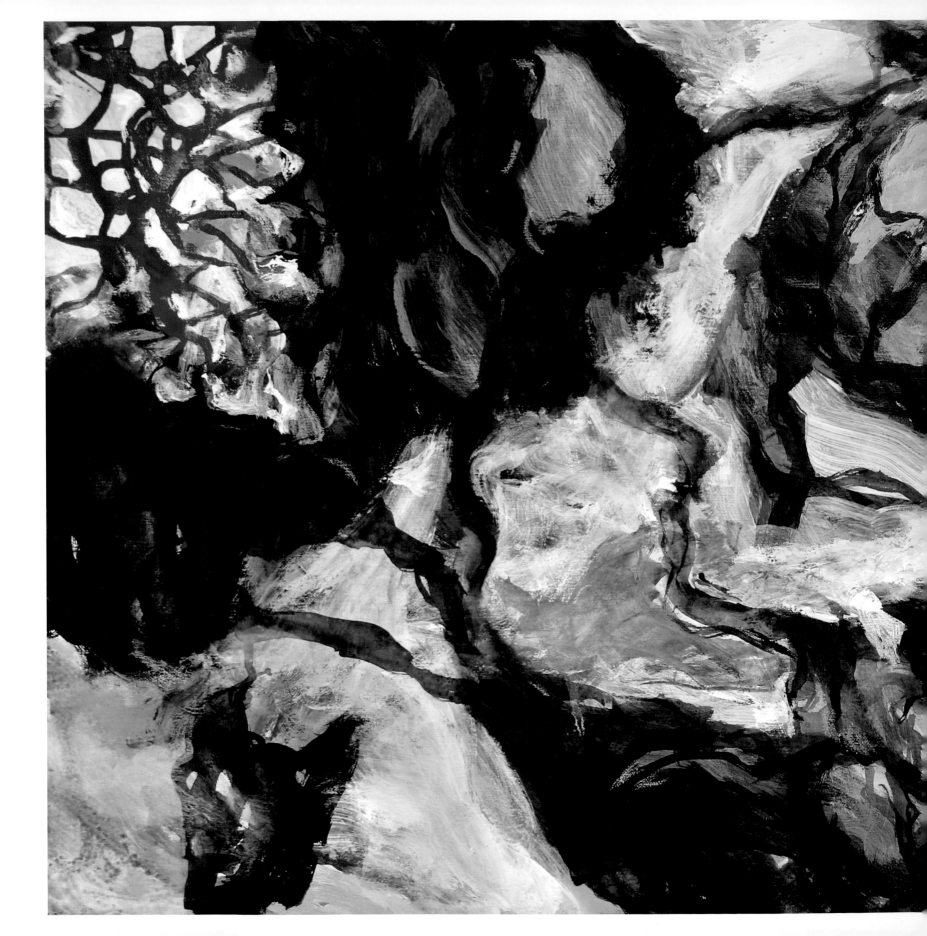

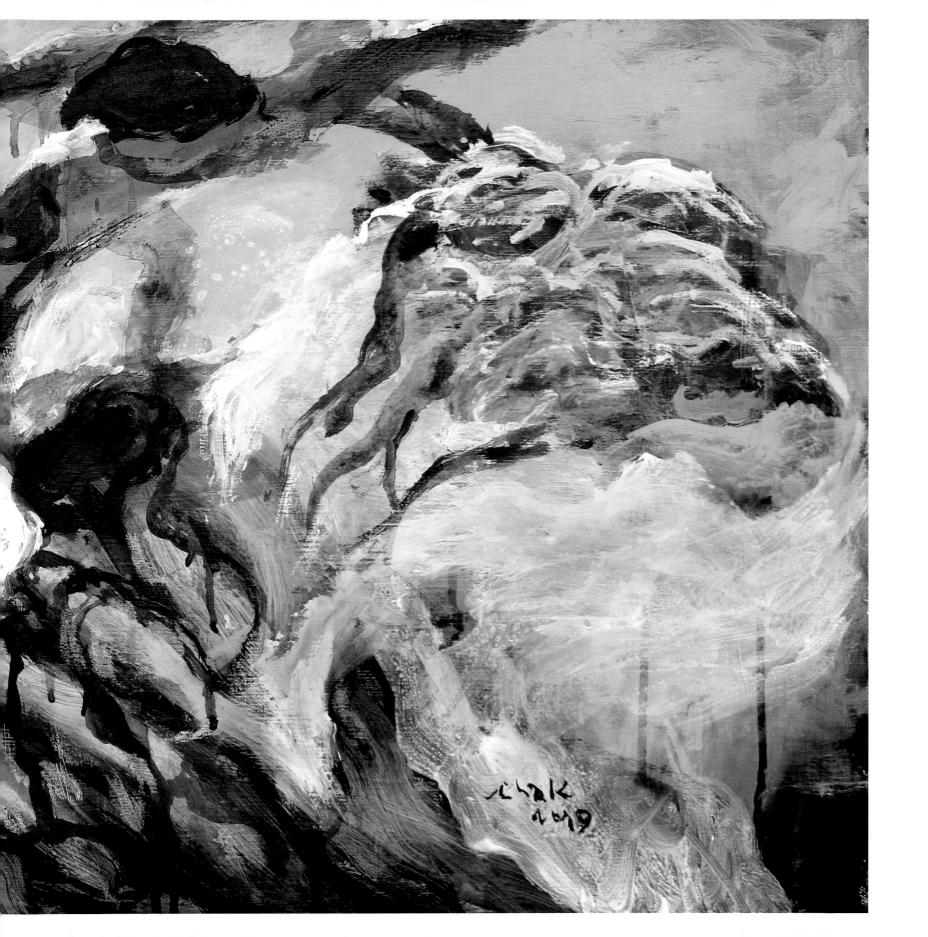

▲

Peach Blossom Grove Escape
暴走中的世外桃園
40.6 x 81.2 cm │ 2019

Masquerading as Flowing Clouds ▶
浮雲的偽裝
40.6 x 60.9 cm │ 2019

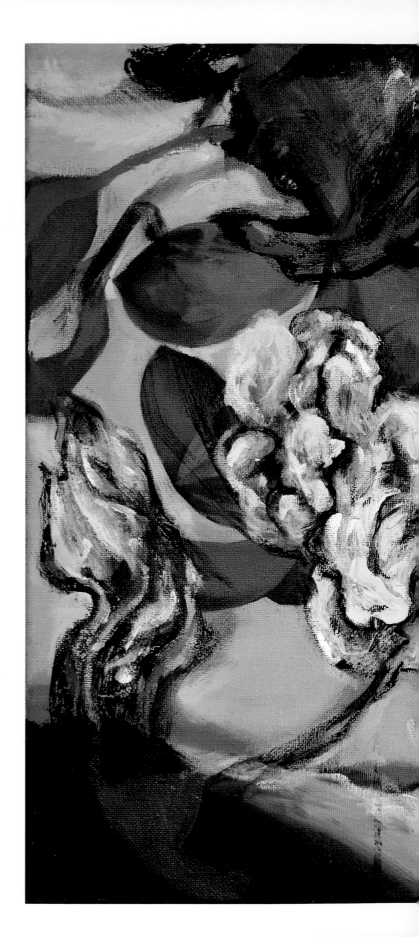

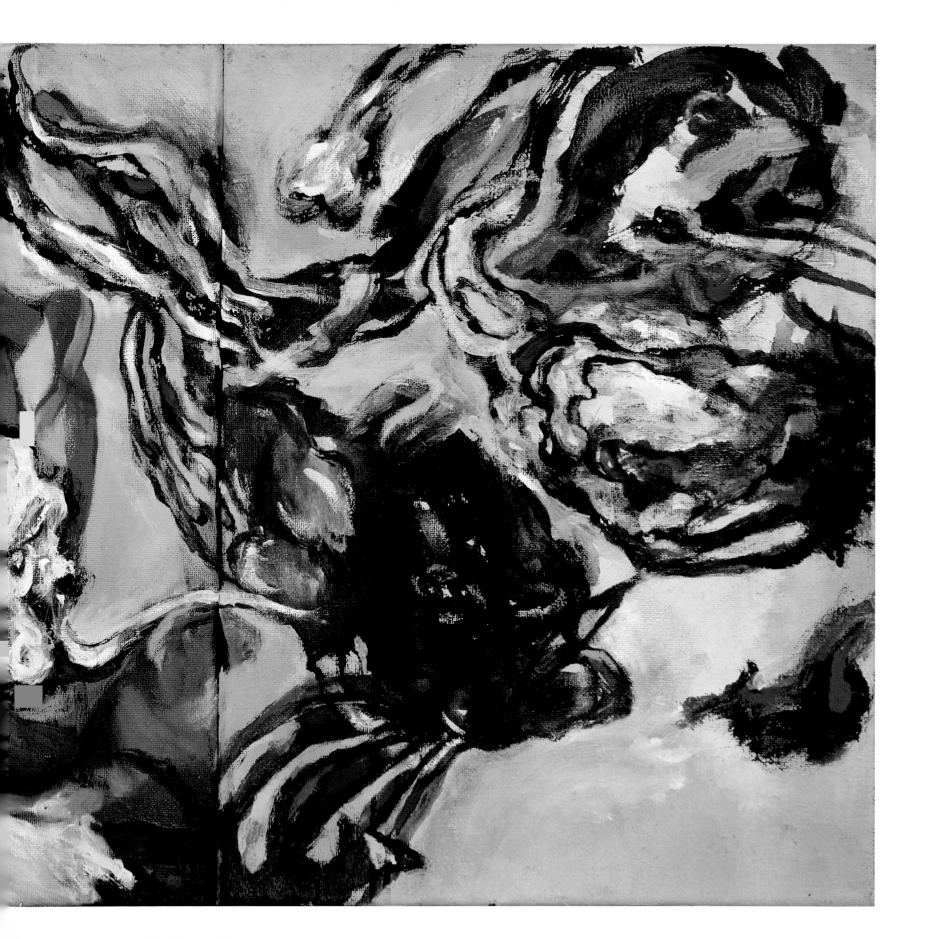

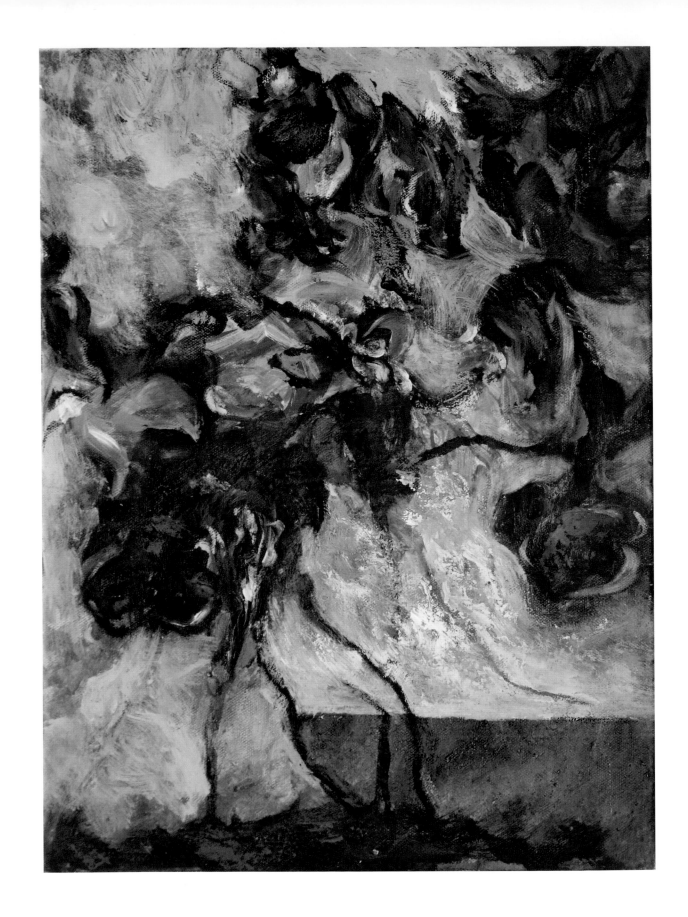

Flowering Sky
花飛滿天
40.6 x 30.4 cm | 2018

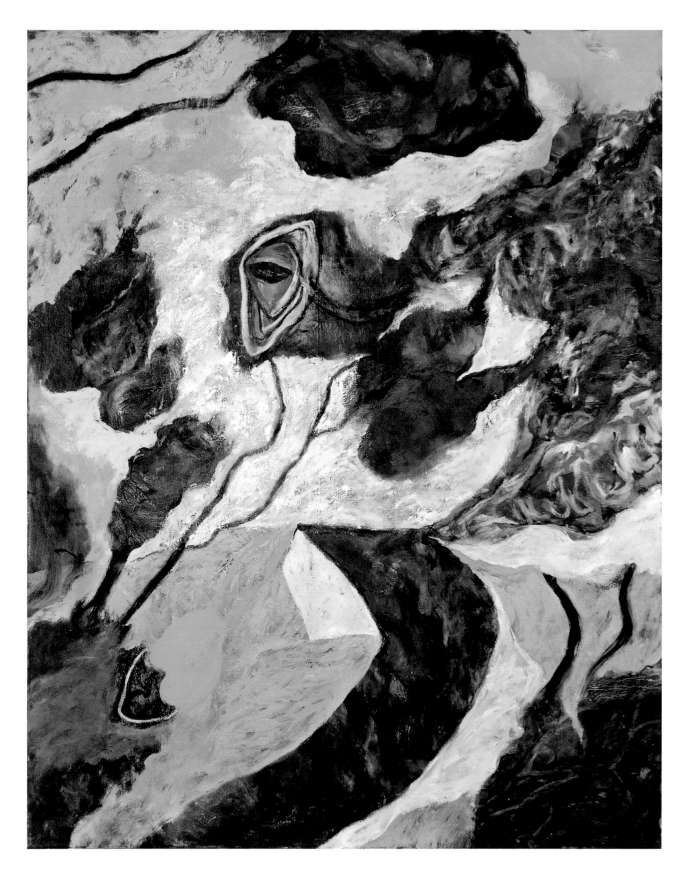

No Escaping Nature
天眼恢恢
102.2 x 76.8 cm │ 2017–19

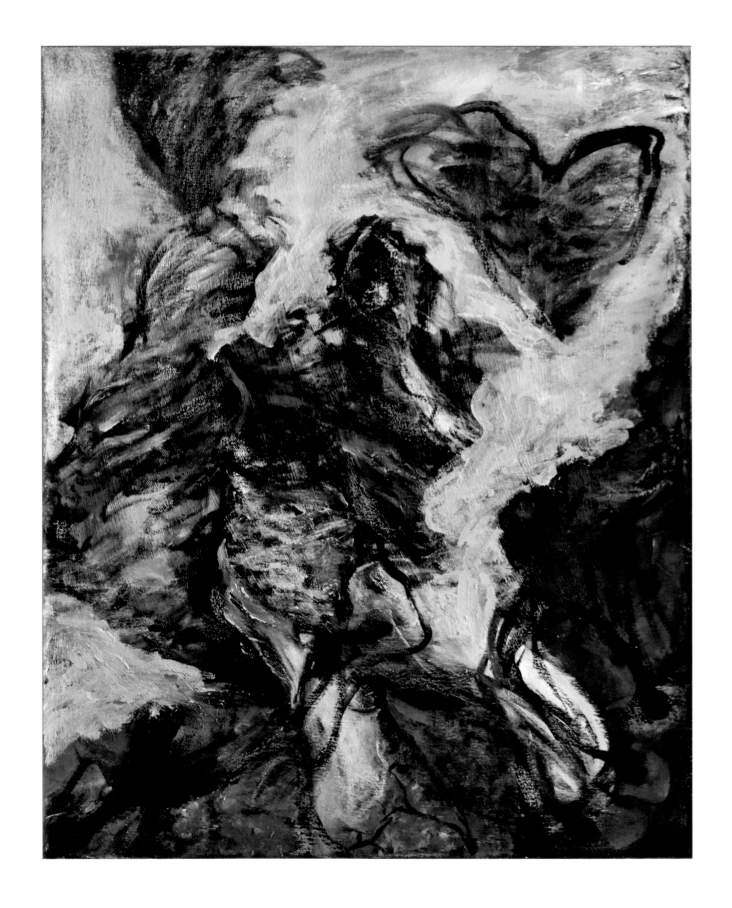

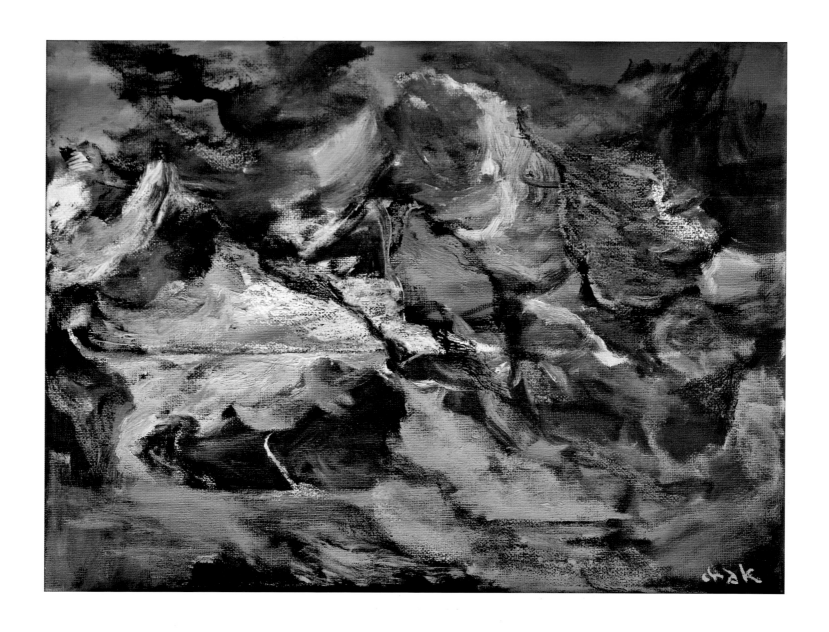

Brook Party
小溪們的派對
30.4 x 40.6 cm | 2019

◄ Nature's Heart Sketch
大自然心臟的速寫
50.8 x 40.6 cm | 2019

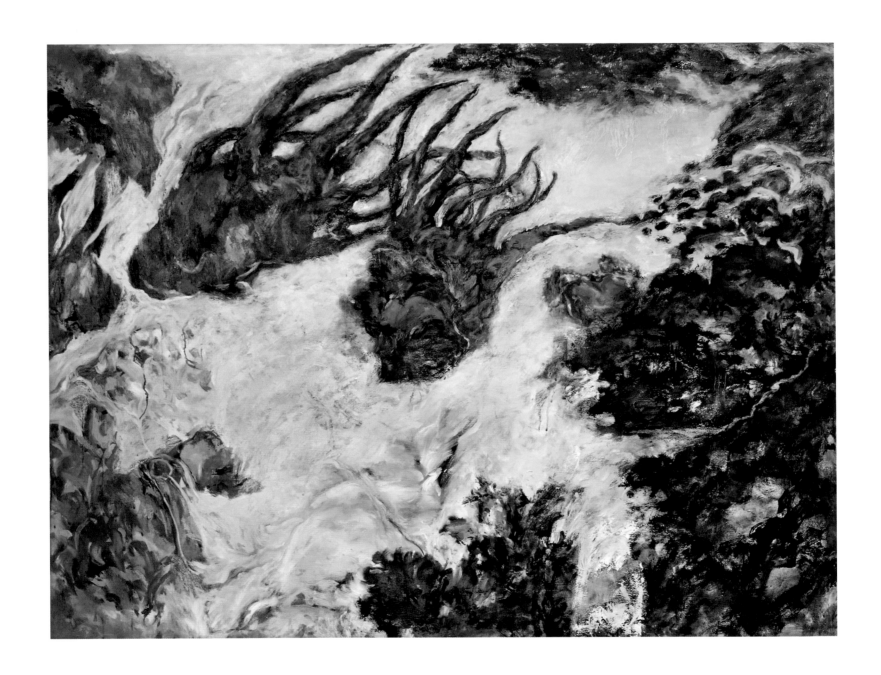

Traveling Couple
旅途中的情侣
41.5 x 56.5 cm | 2011–18

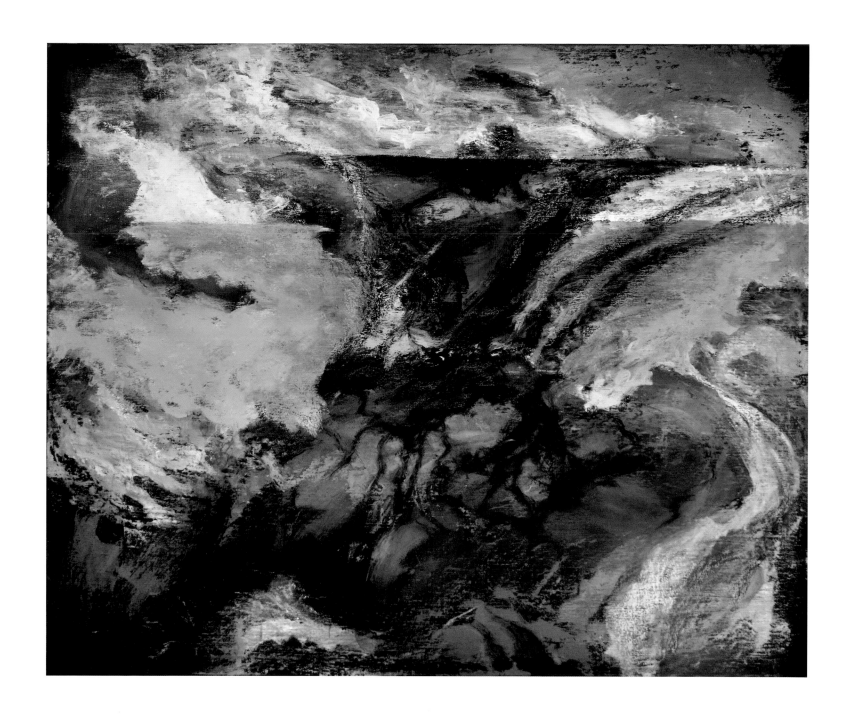

Coming Storm
暴風雨的來臨
50.1 x 59.7 cm │ 2019

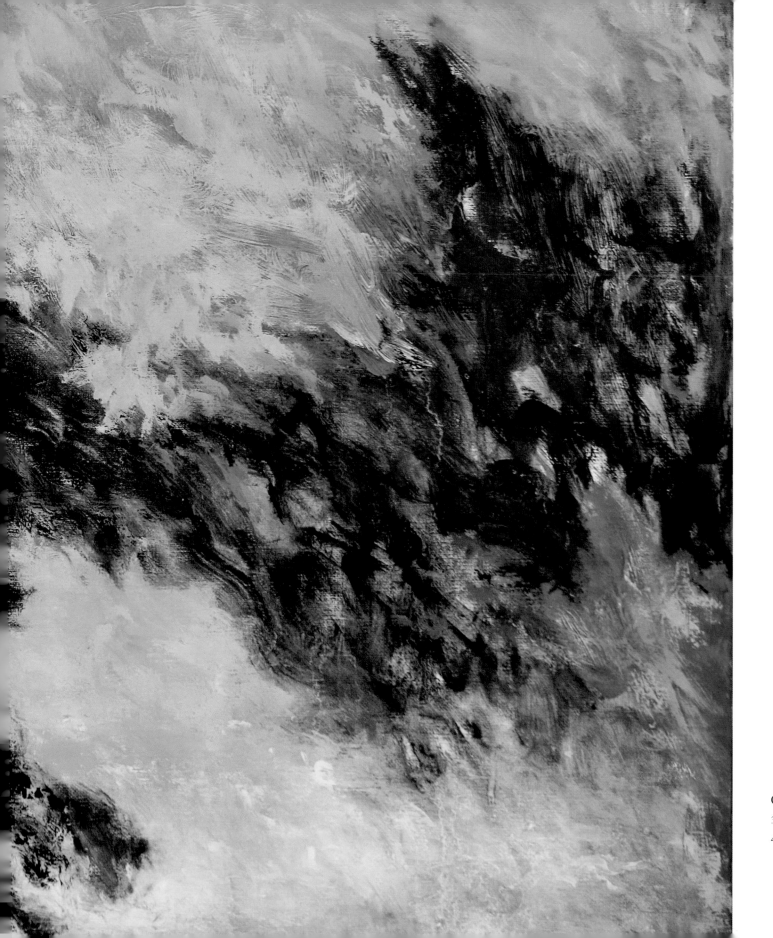

Golden Dusk
金色的黄昏
41.2 x 64.1 cm ｜ 2019

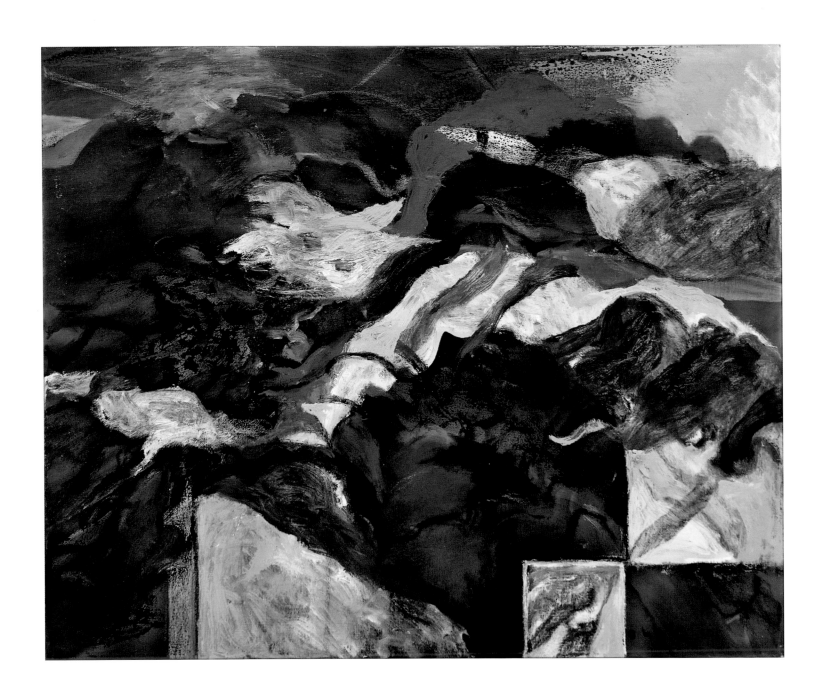

Postmodern Landscape
後現代的風景
50.1 x 59.7 cm │ 2018

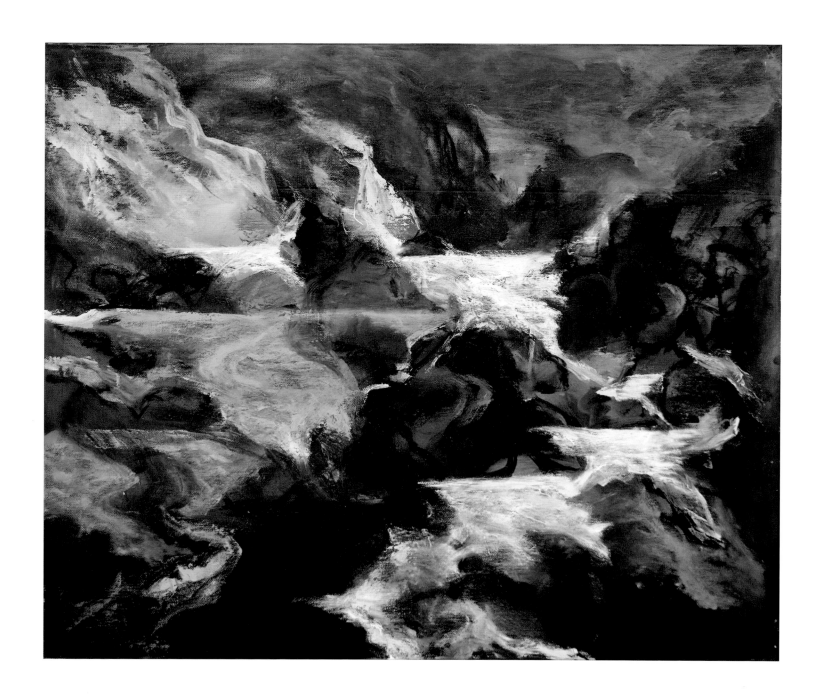

Co-existence of the Clam and the Waving Sea
海的兩面──風平浪靜與波濤洶湧
50.1 x 59.7 cm | 2019

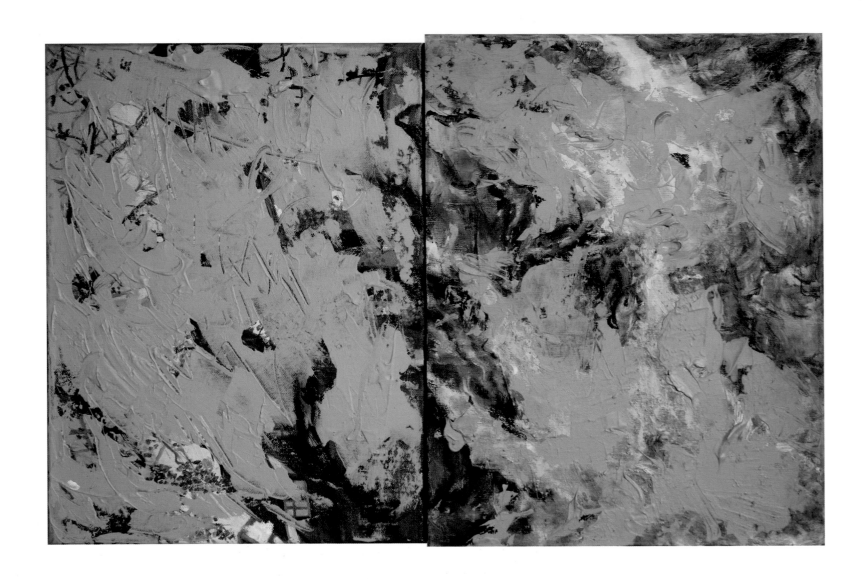

Azure Sea
蔚藍的海洋
41.2 x 62.2 cm │ 2018

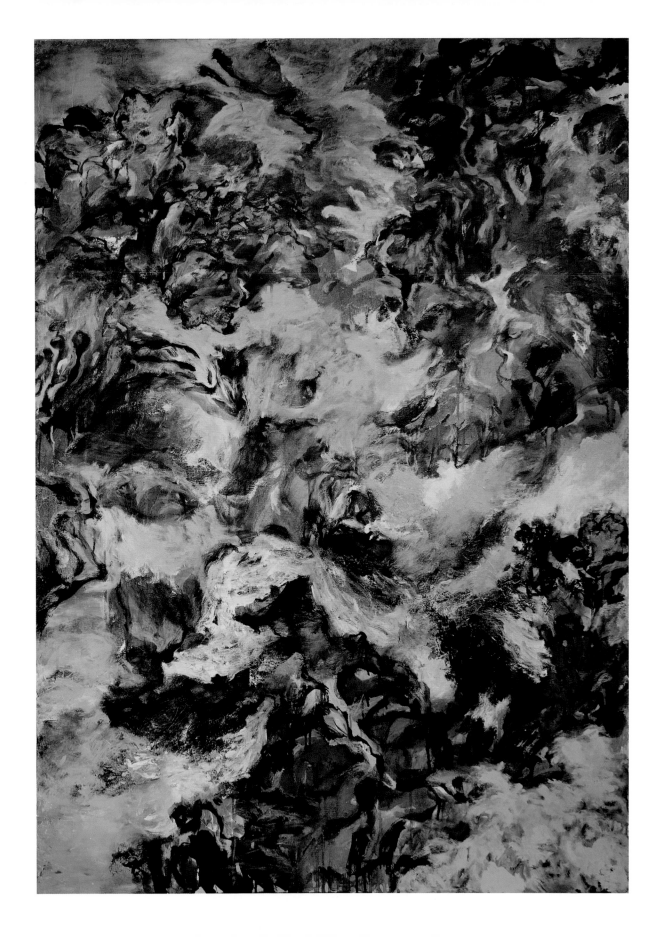

Vanishing the Frog
被消失的怒蛙
56.5 x 39 cm │ 2019

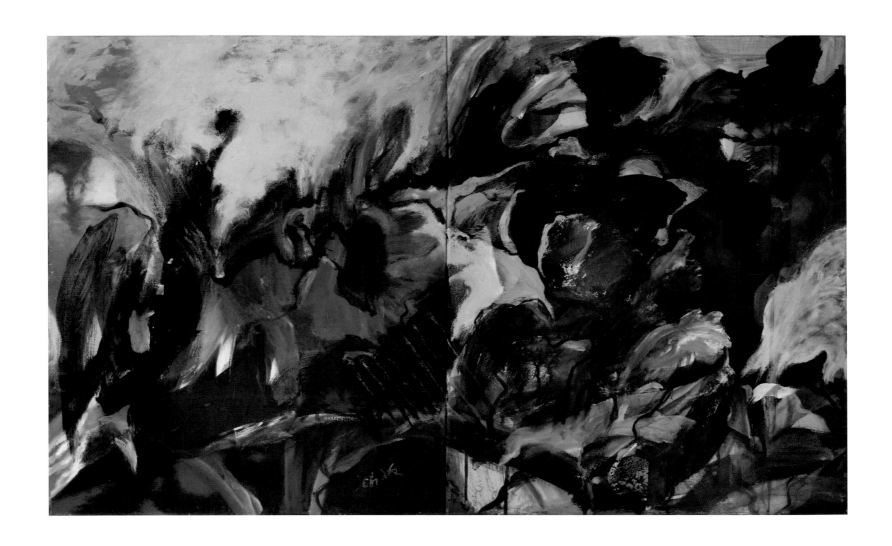

Sakura Blossoms
櫻花
59.8 x 100.2 cm │ 2019

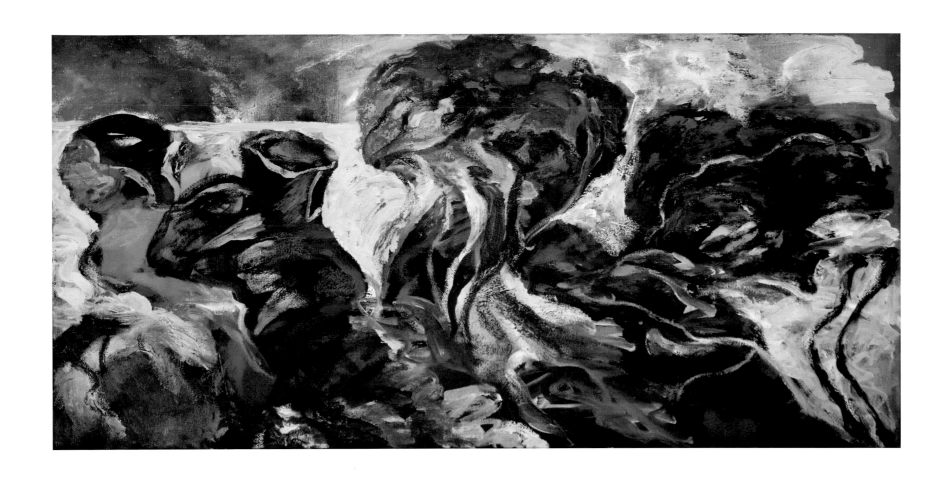

Greetings from the Greenery
植物的寒暄
29.8 x 61 cm │ 2019

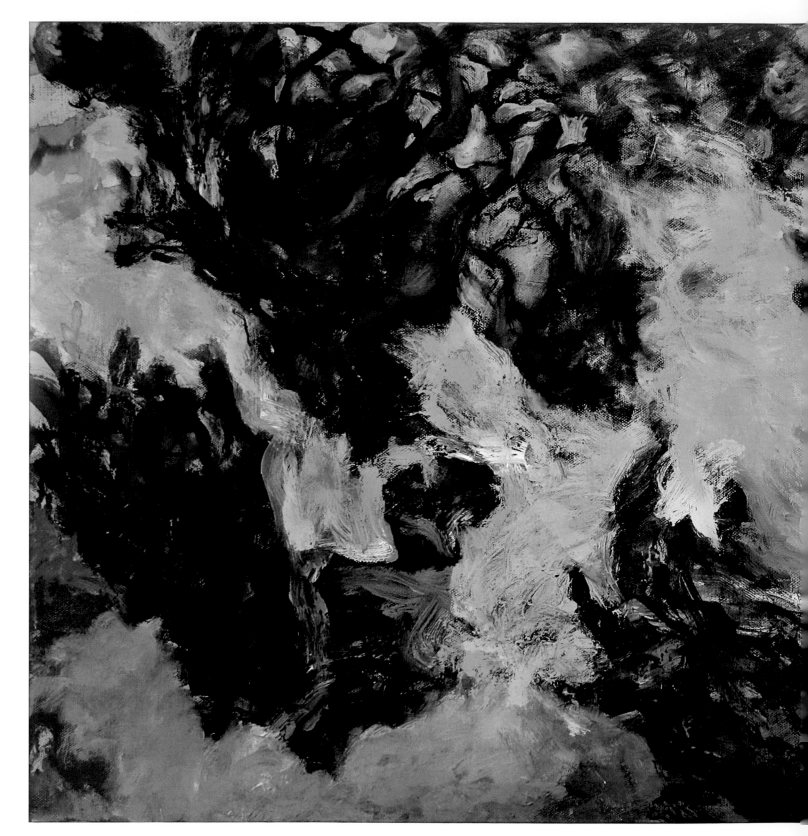

Autumn Blue
秋天的感觸
45.7 x 92 cm | 2019

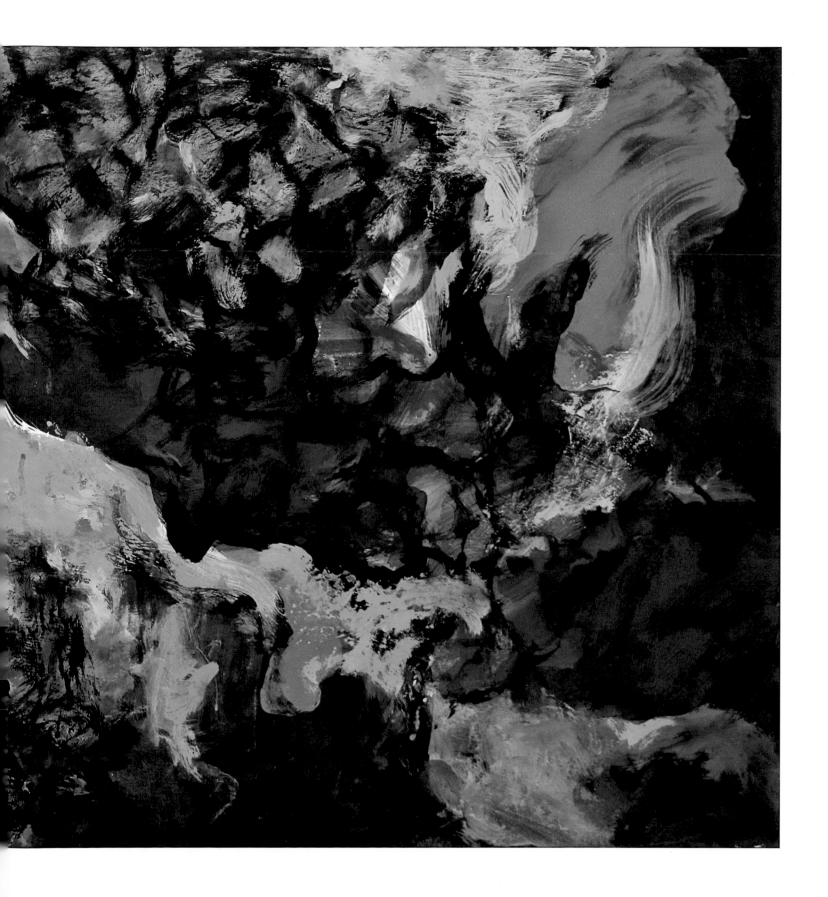

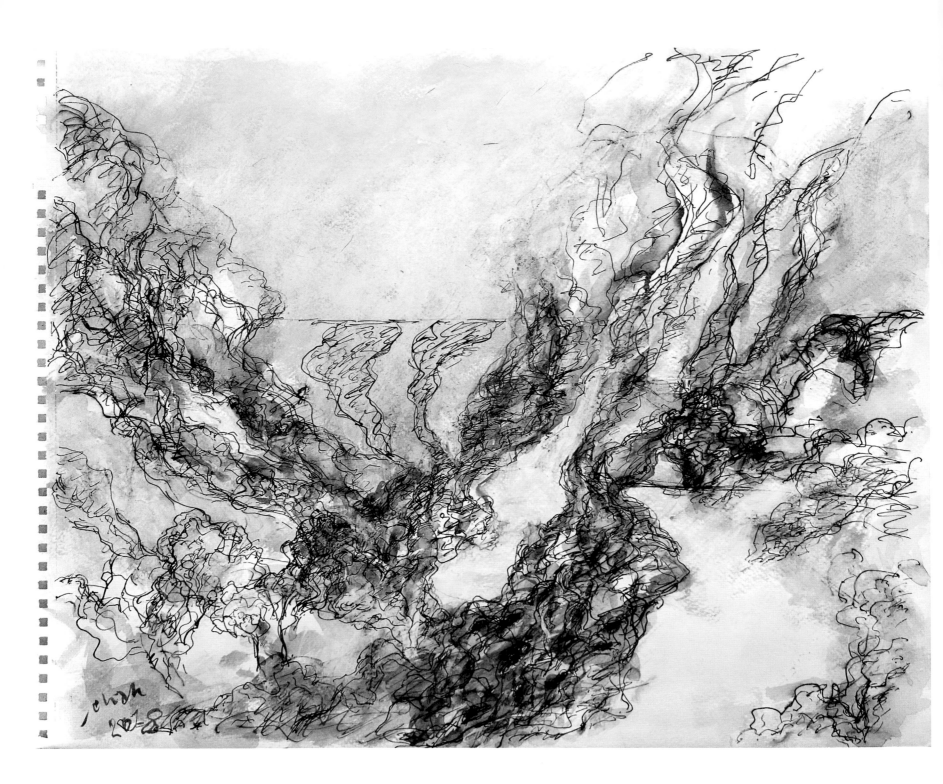

繪圖 Drawings

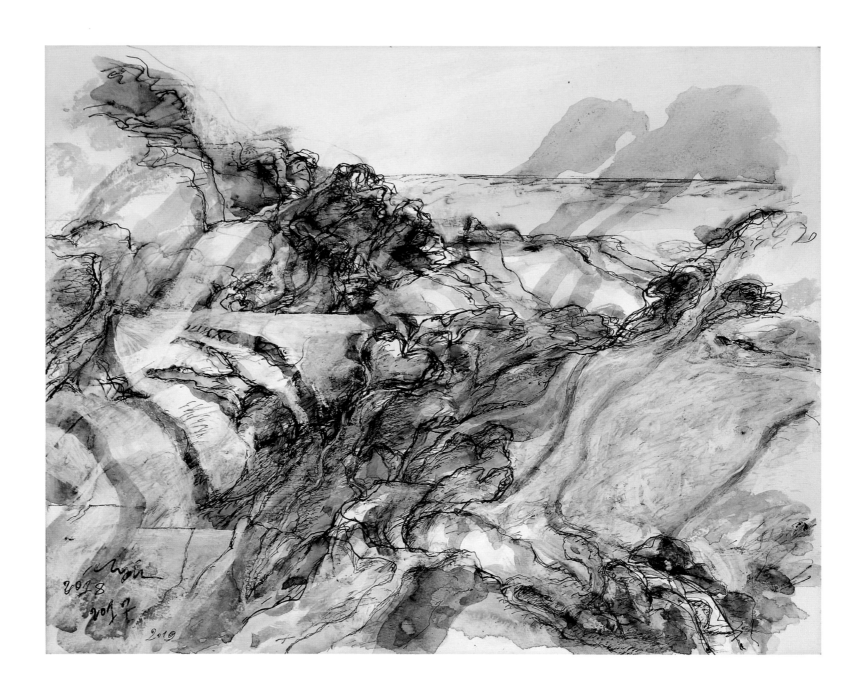

Heartland
心臟地帶
32 x 41 cm | 2017–19

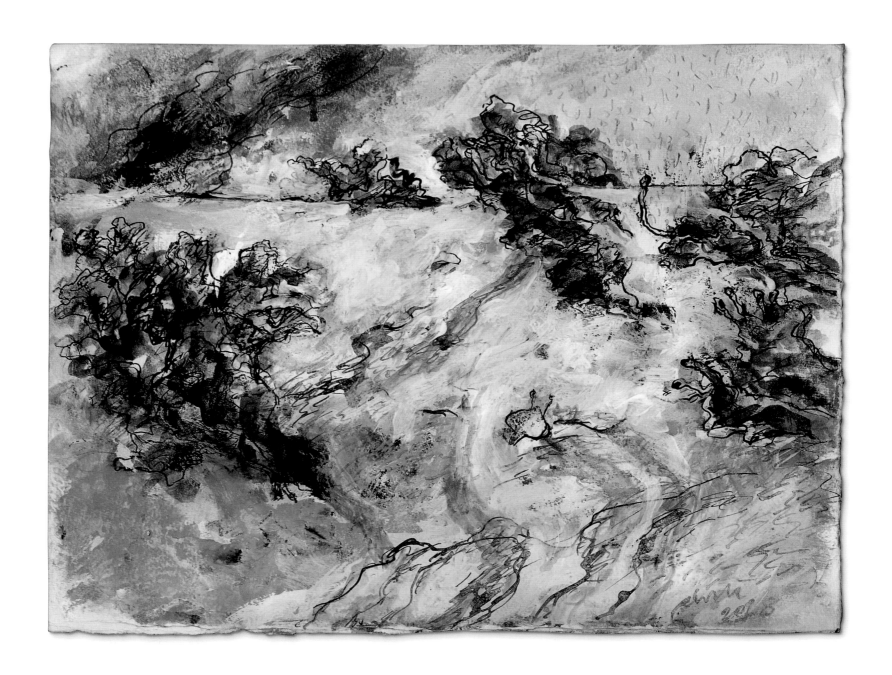

A Nice Breeze
一習輕快涼風
32 x 41 cm ｜ 2018

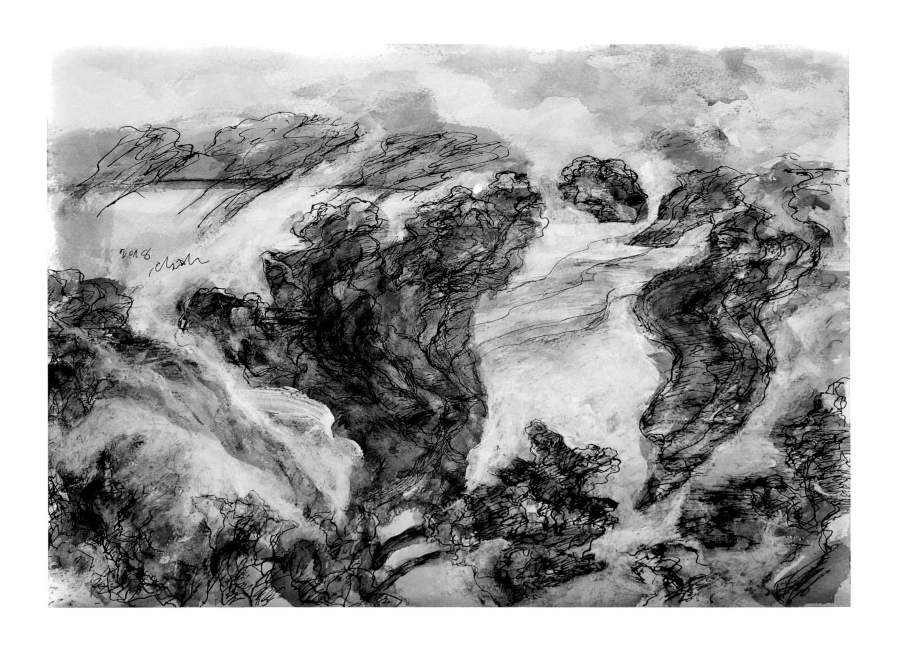

White Clouds as Hydrogen Balloons
恰似氫氣球的白雲
29.5 x 41.9 cm │ 2018

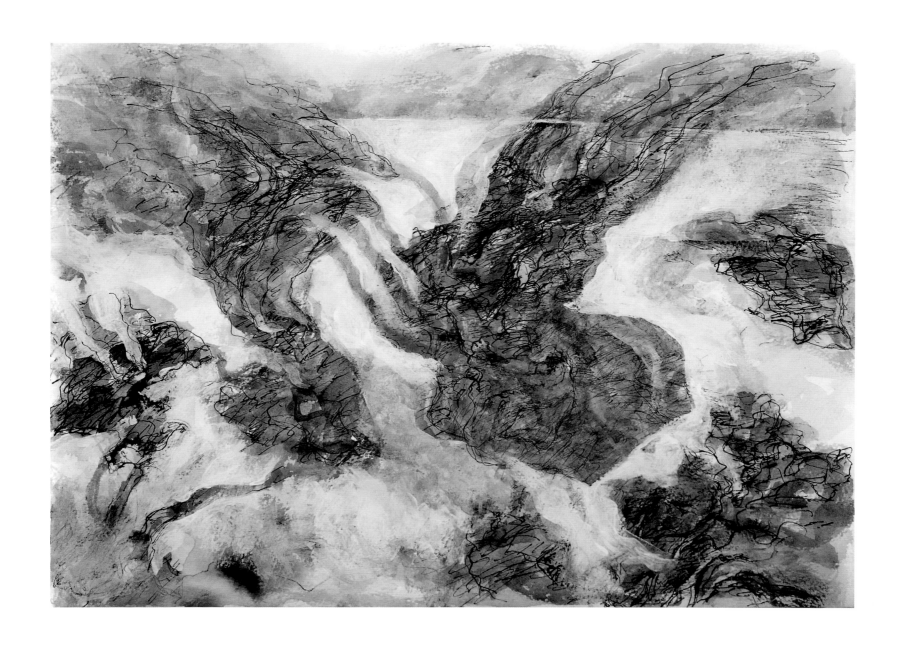

Dance of the Tako
舞步章魚
29.5 x 41.9 cm | 2019

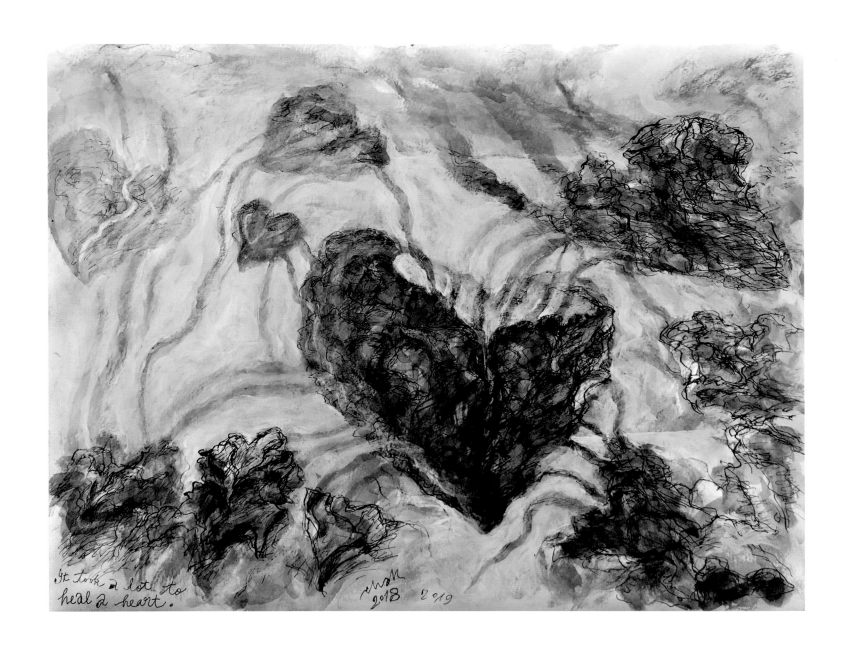

It took a lot to heal a heart.

chan
2018 2019

Healing Hearts
心病還得心藥治
30 x 40 cm │ 2018–19

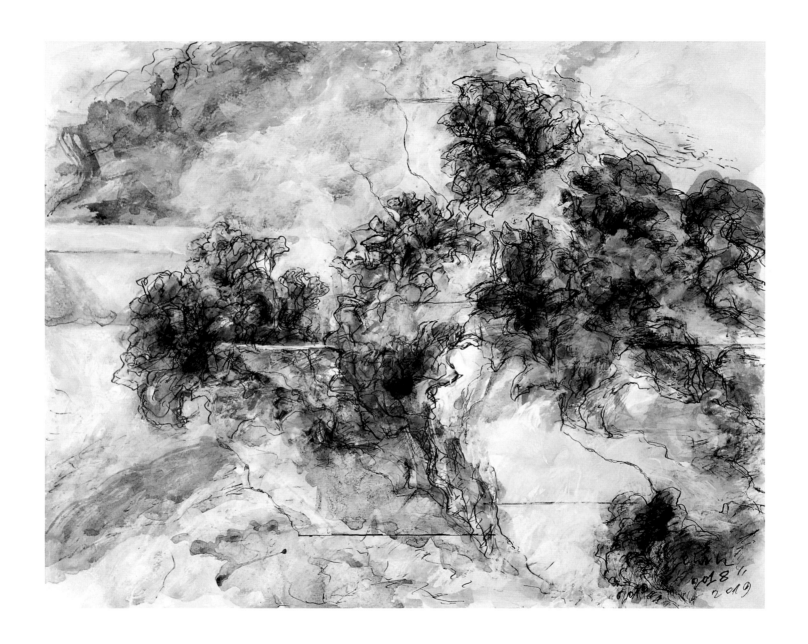

What a Yellow Evening
好個淡月昏黃
32 x 41 cm │ 2018–19

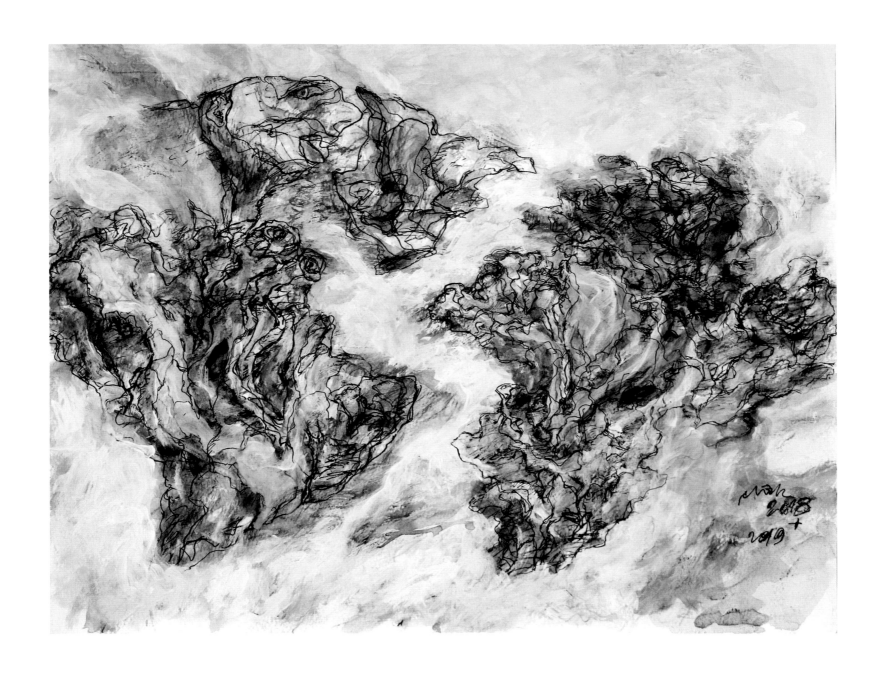

The Tako and I
章魚與我
30 x 40 cm | 2018–19

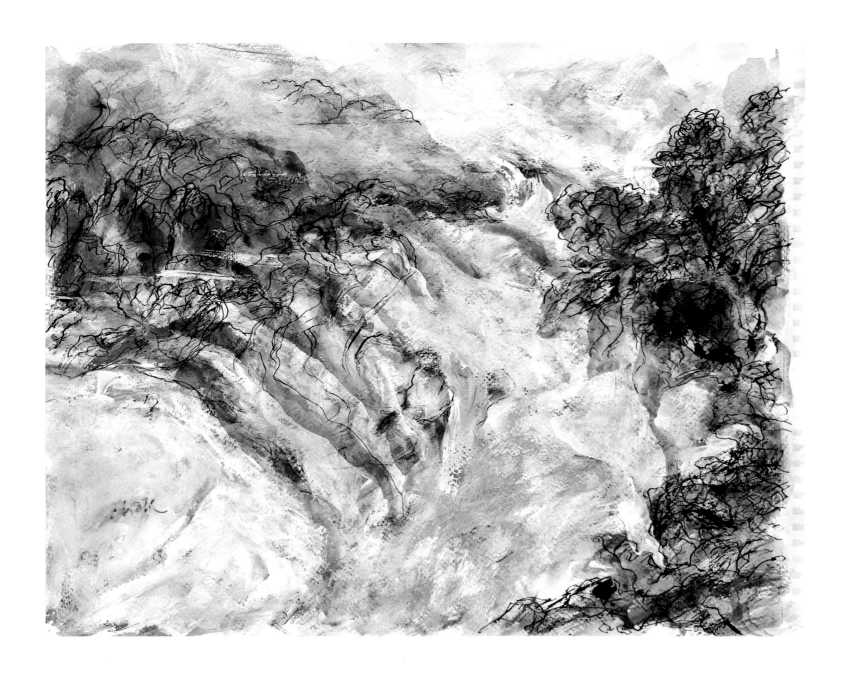

Fogged in to Port
滯留港口的遲霧
31 x 42 cm | 2018

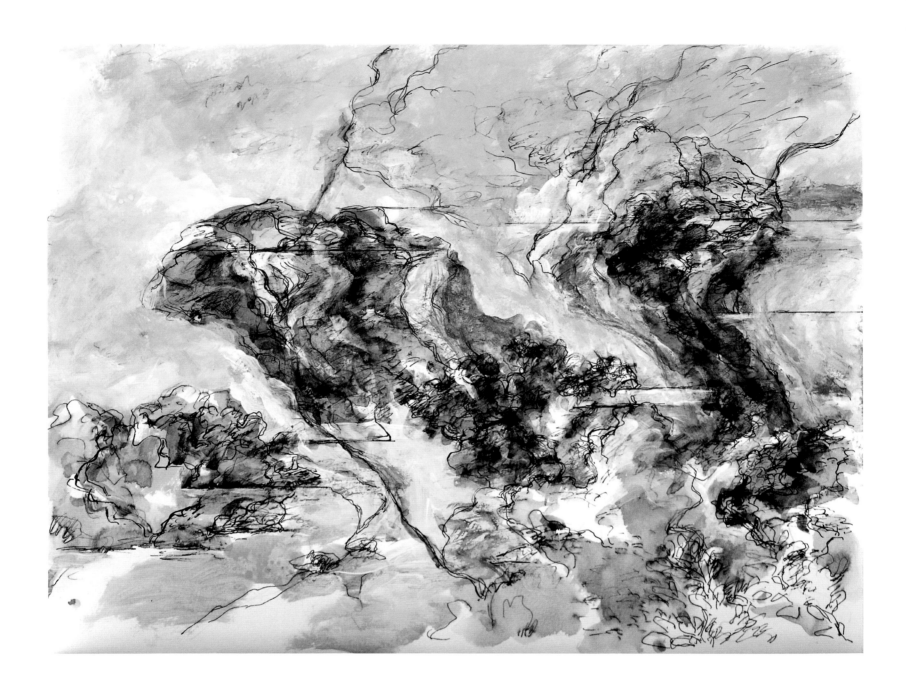

Nice Hike
愉快的遠足
30 x 40 cm │ 2019

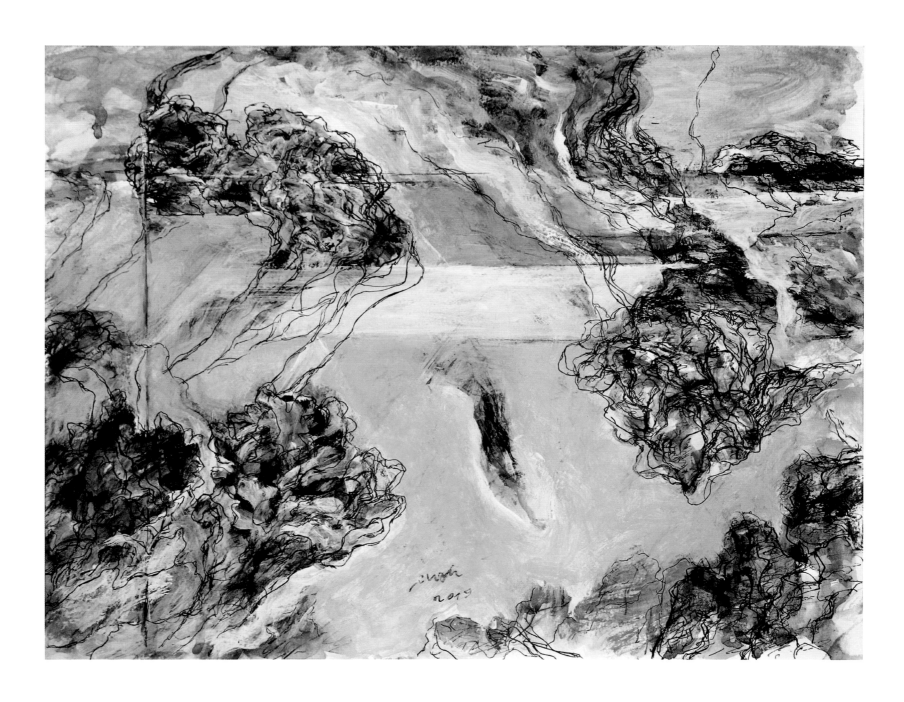

Lonesome Islet
寂寞的小島
30 x 40 cm | 2019

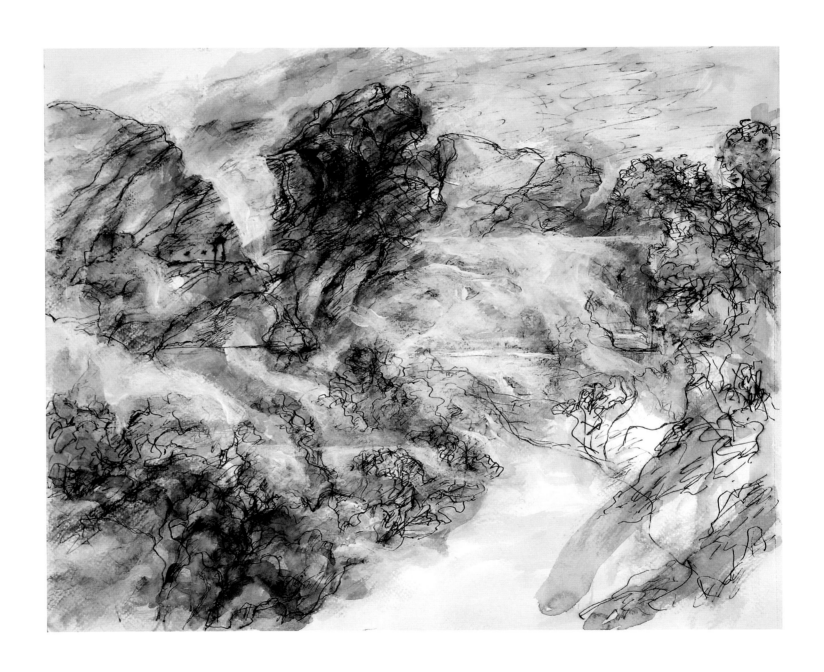

Remains of the Village
古村莊的殘存
32 x 41 cm | 2018

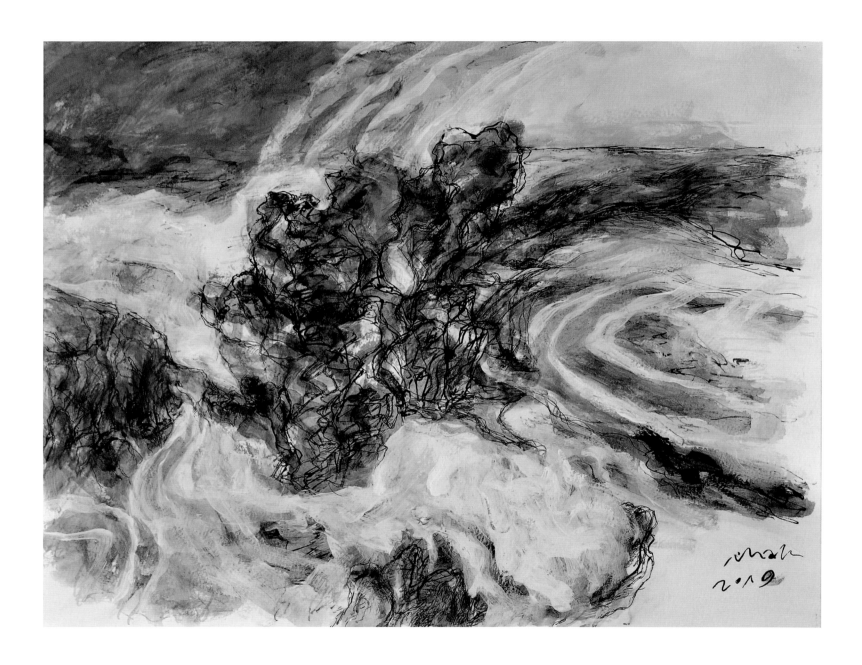

Sketch for The Big Blue
海天一色 (草稿)
30 x 40 cm | 2018

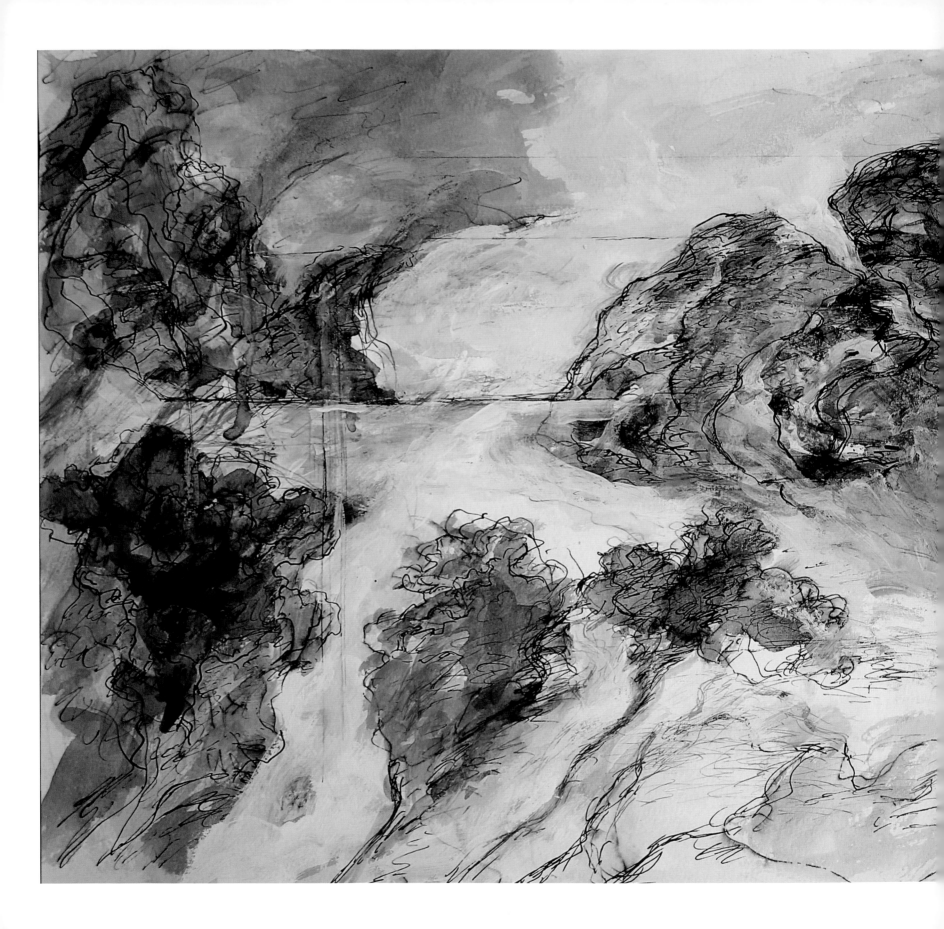

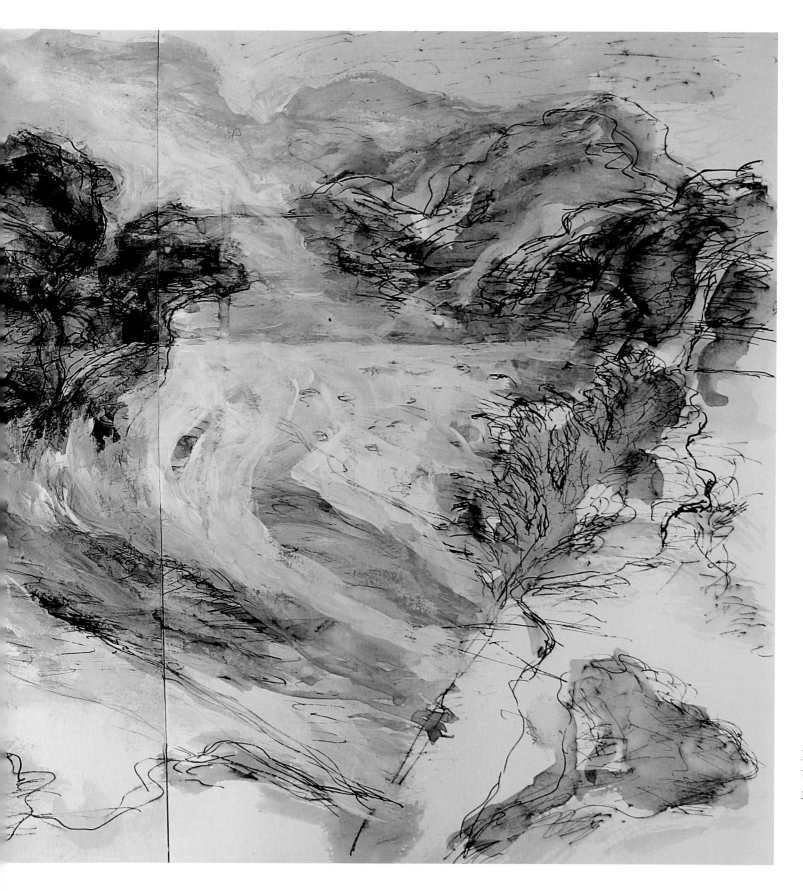

Long Walk
漫長遠足
30.1 x 62.8 cm | 2019

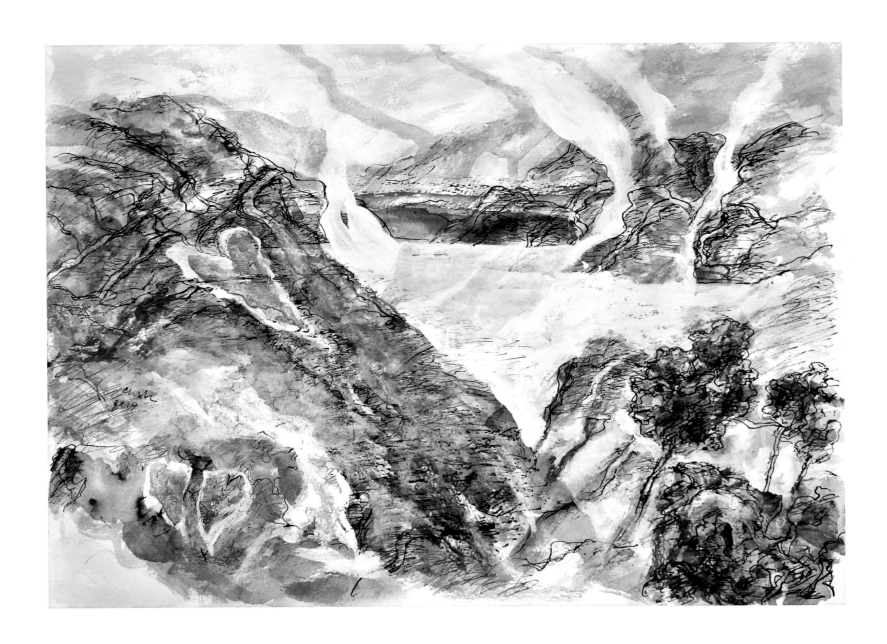

Three Hearts of Gold
黃金打造的三顆心
29.8 x 42 cm │ 2019

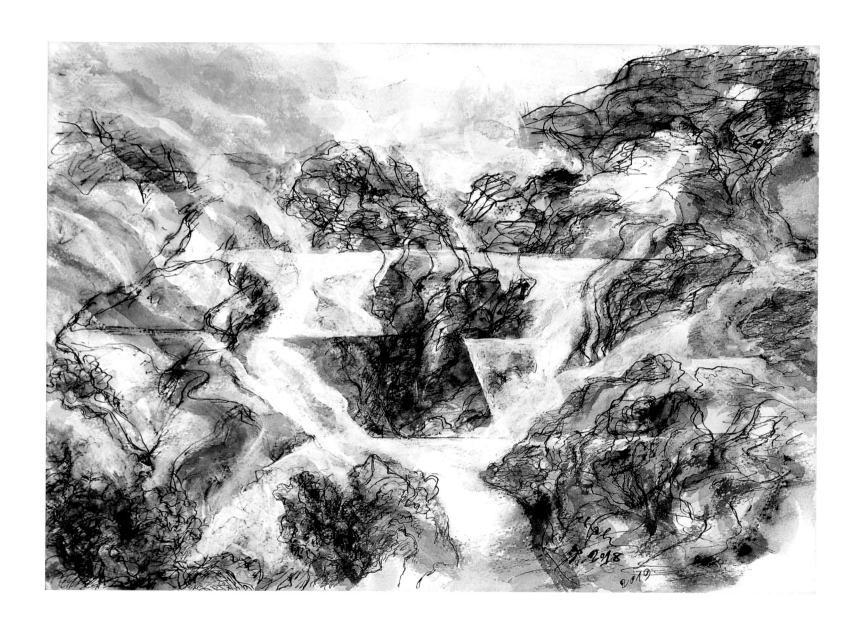

Sketch for Co-existence of the Clam and the Waving Sea

海的兩面──風平浪靜與波濤洶湧 (草稿)

32 x 41 cm │ 2018–19

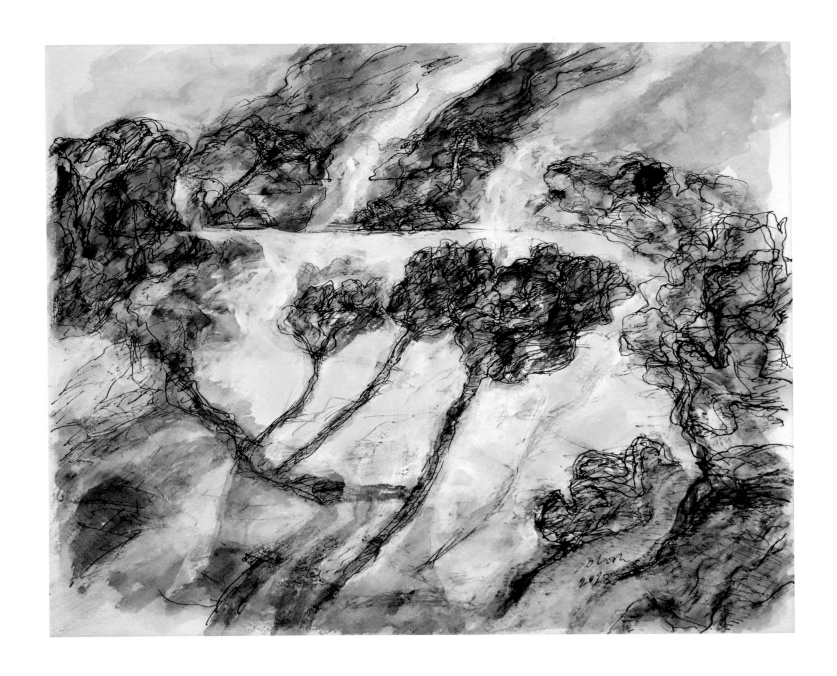

The Three Tenors in Concert after the Typhoon
颱風肆虐後的三大男高音演唱會
32 x 41 cm | 2018

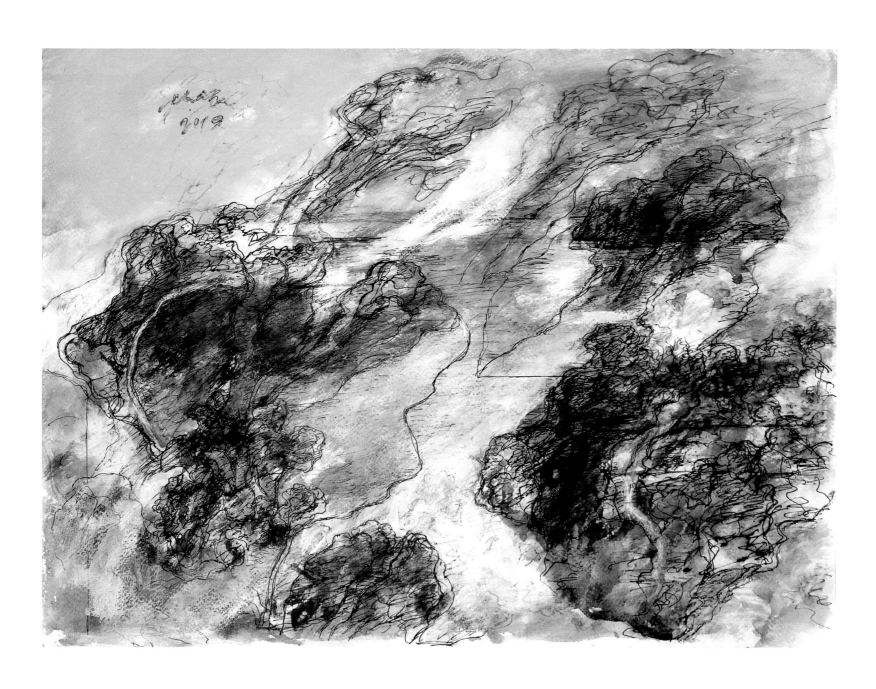

Yesterday's Light Blue Sky
昨夜天空真蔚藍
32 x 41 cm │ 2019

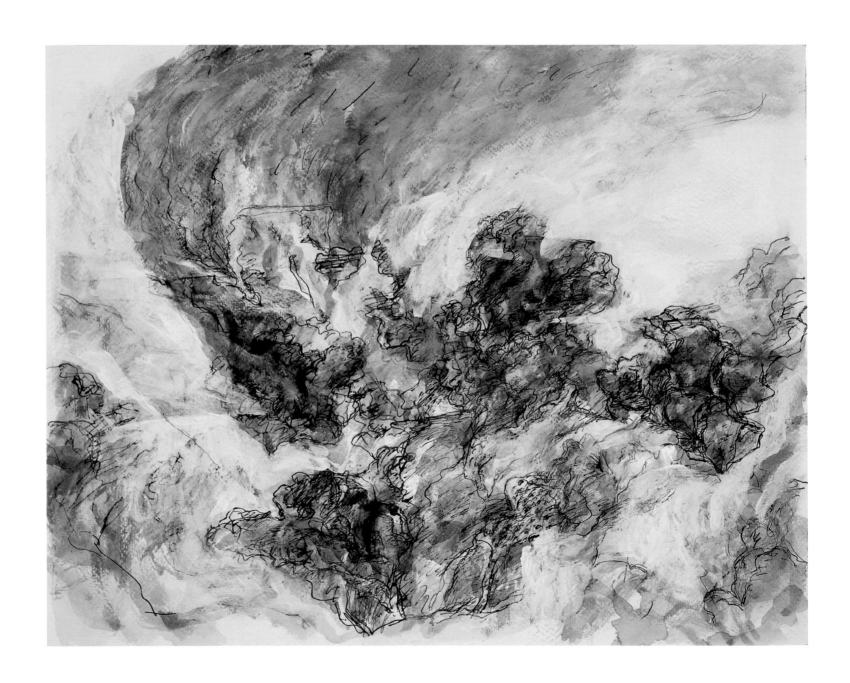

Shifting Wind I
無定向風一號
32 x 41 cm | 2018

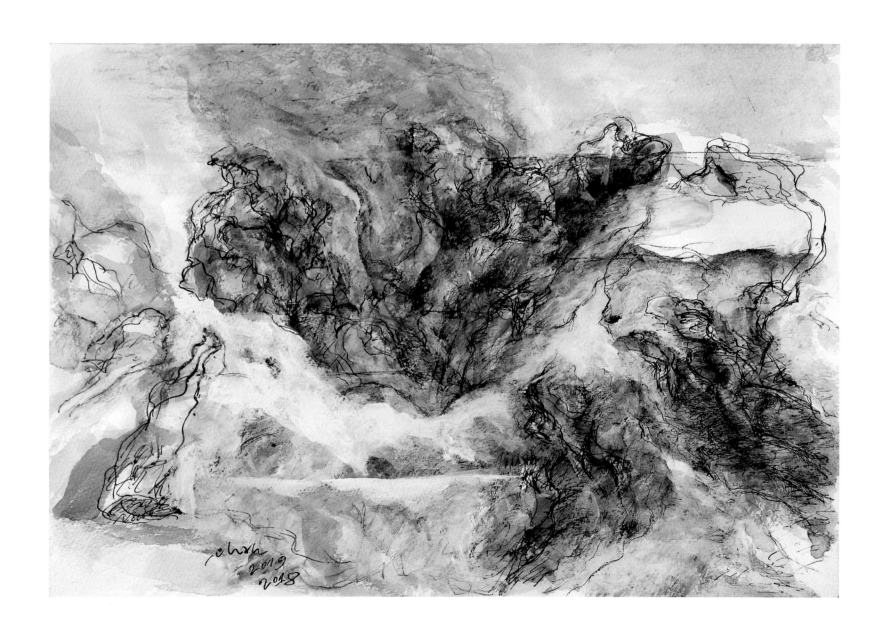

Shifting Wind II
無定向風二號
32 x 41 cm │ 2018–19

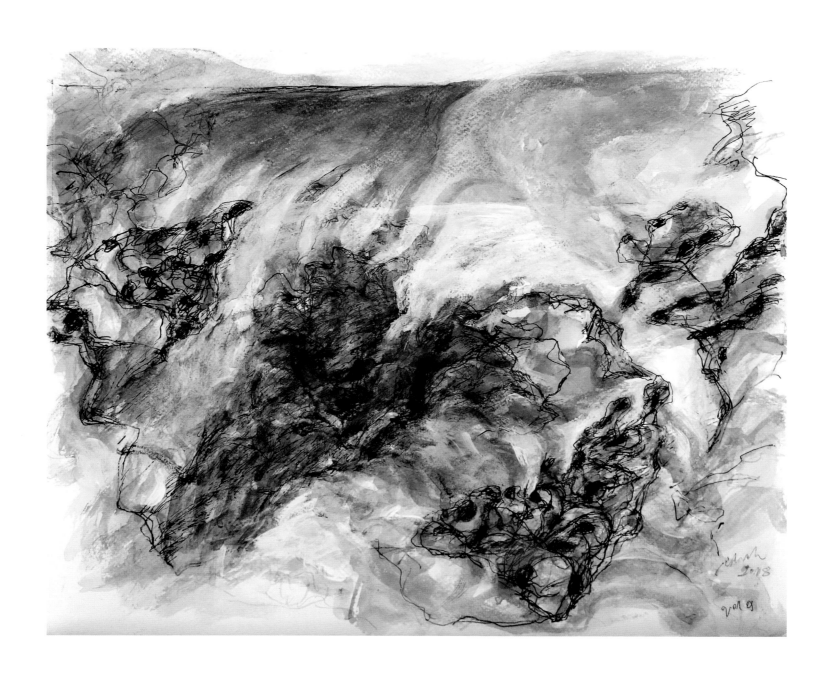

The Heavens Are All Eyes
人在做天在看
32 x 41 cm | 2018–19

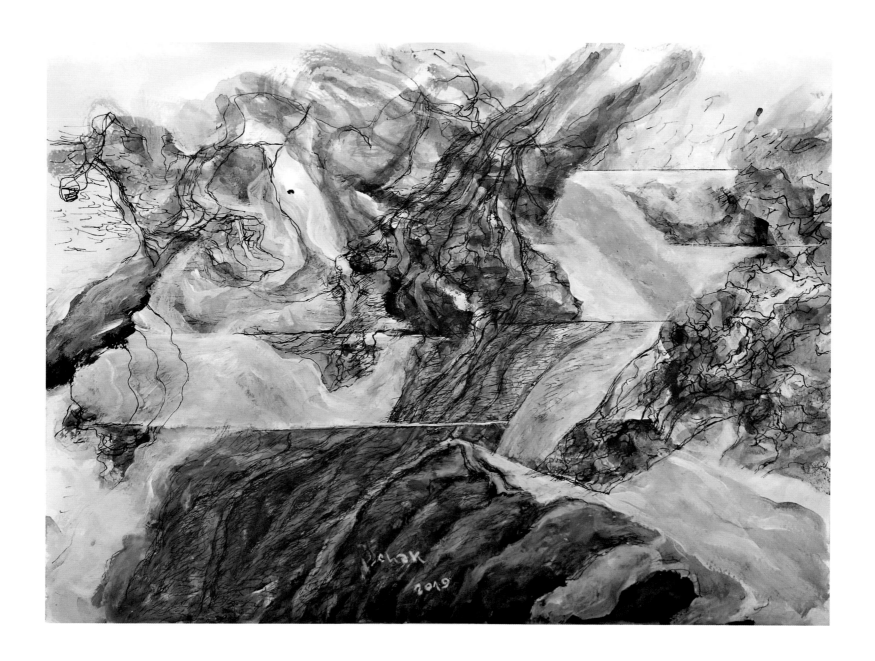

Brutal Grandfather Sun
暴戾的太陽公公
30 x 40 cm | 2019

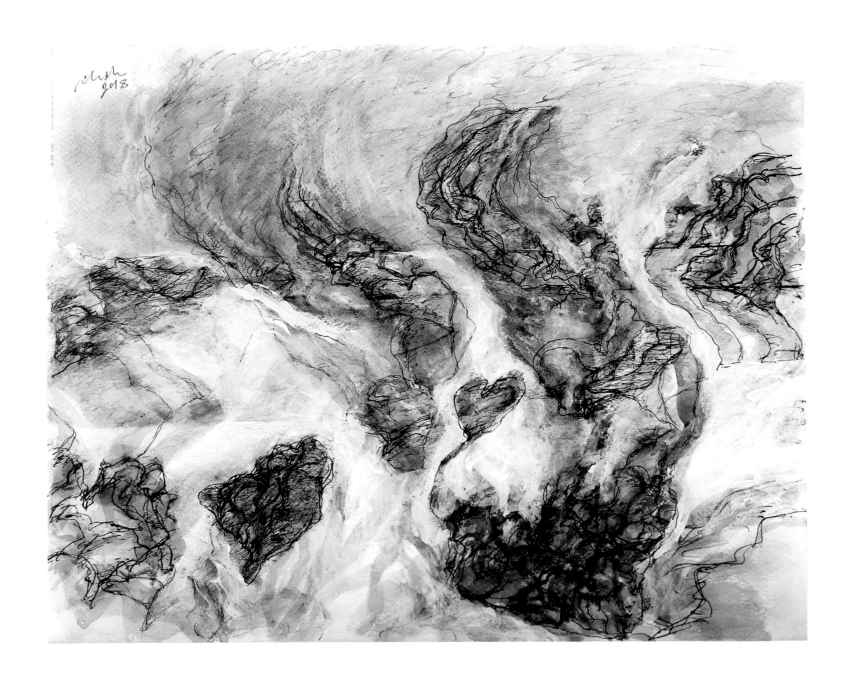

Six Hearts + A Few Damaged More
六顆+好些破碎的心
32 x 41 cm | 2018

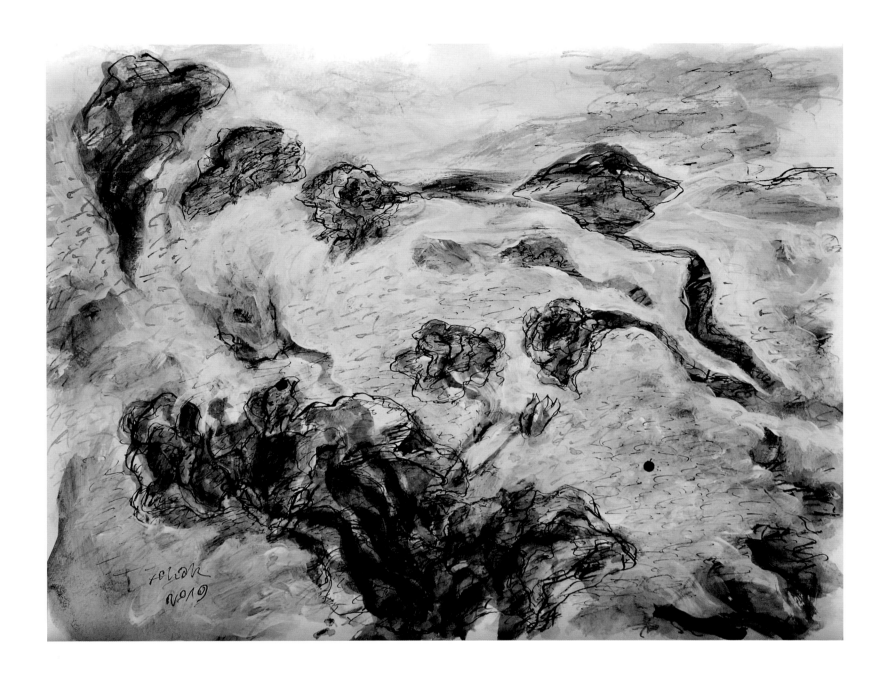

Winter Jasmine
迎春花
30 x 40 cm | 2019

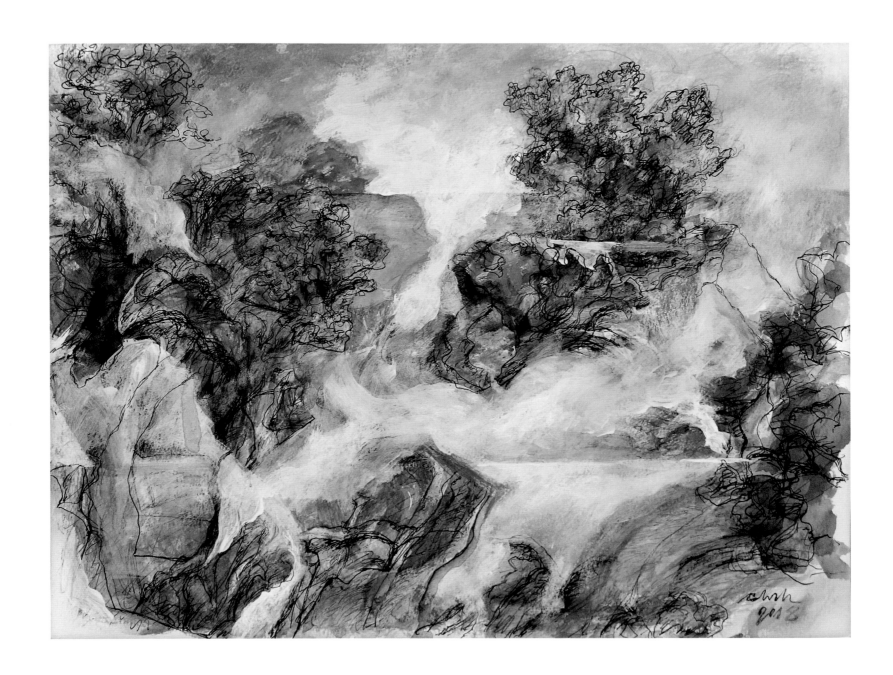

Remains of the Climbing Trees
殘留的樹出牆
30 x 40 cm | 2018

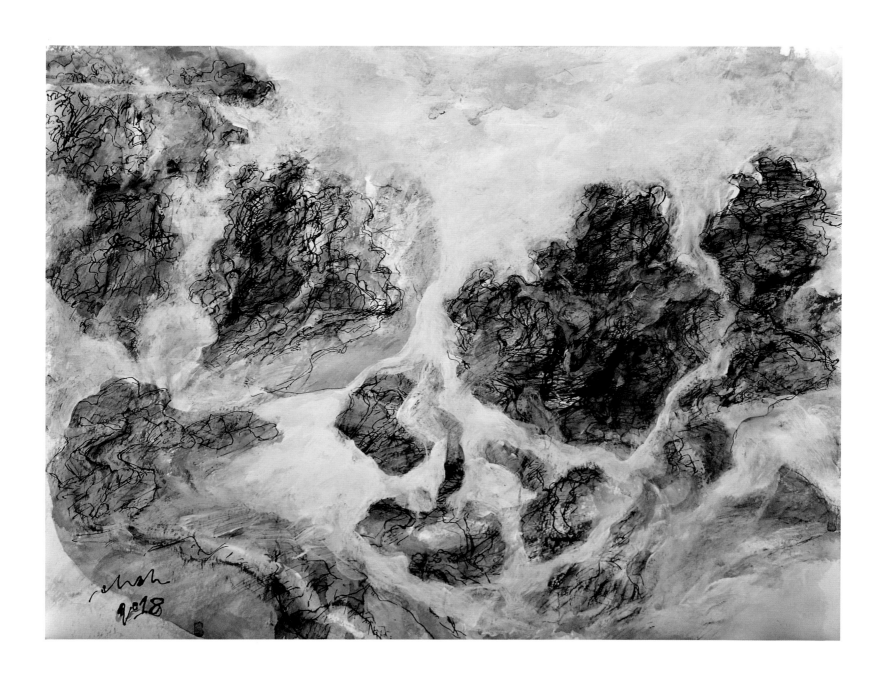

Jigsaw Landscape
嘔啞嘲哳的風景
30 x 40 cm | 2018

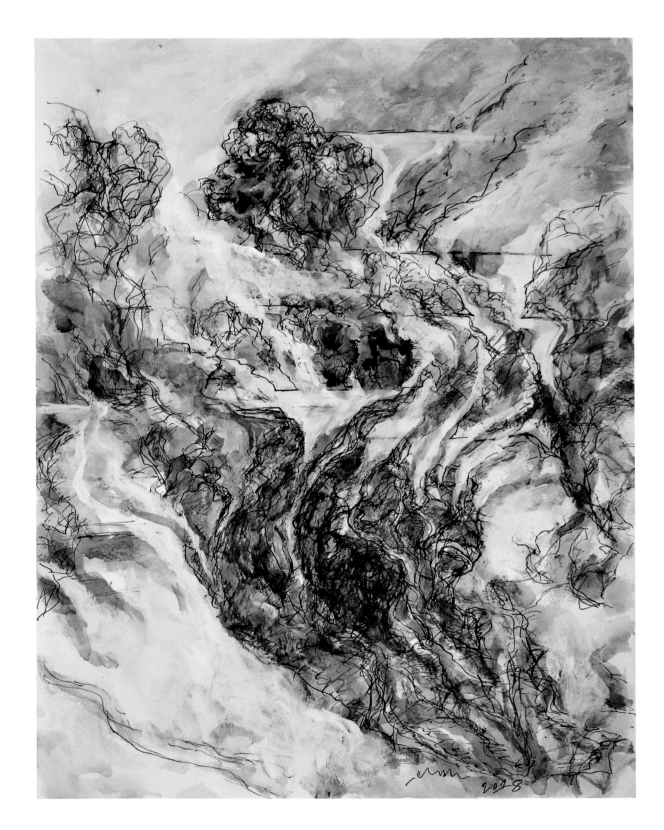

Sketch for
Brotherhood of Streams
小溪與河流的滙流 (草稿)
42 x 29.8 cm | 2018

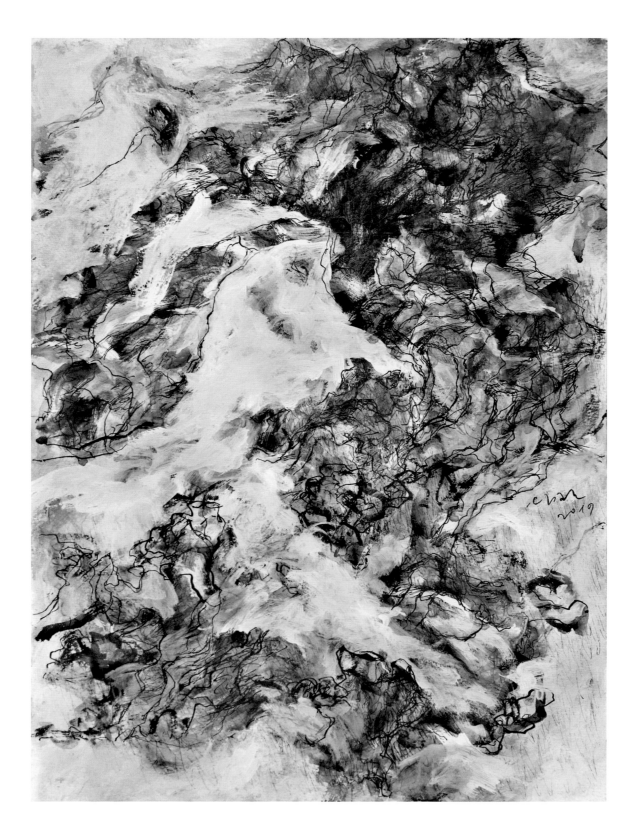

The Green Hill We Climbed
我們攀爬的青山
40 x 30 cm | 2019

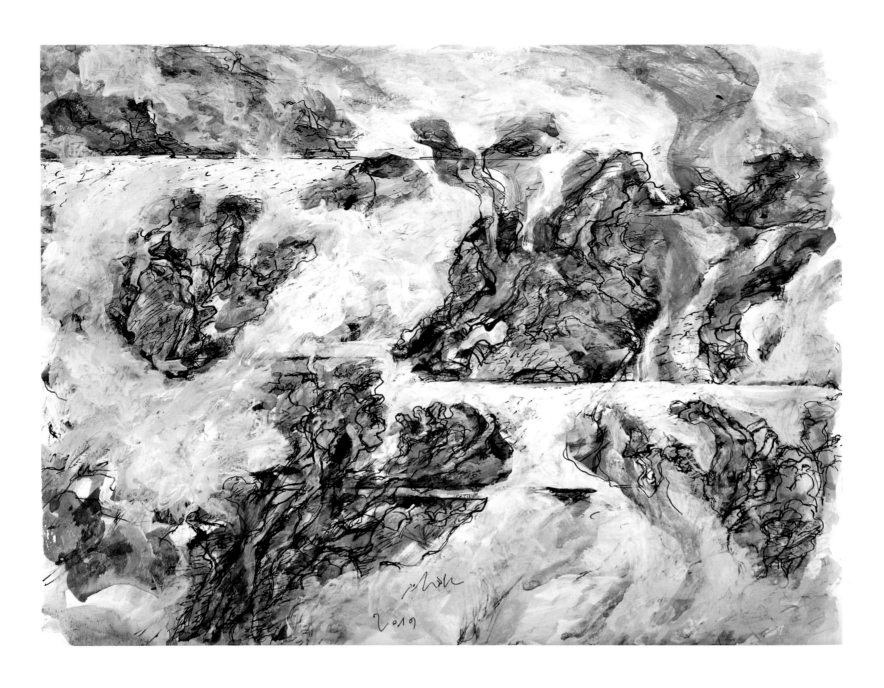

Distant Horizons
遠方的水平線
30 x 40 cm │ 2019

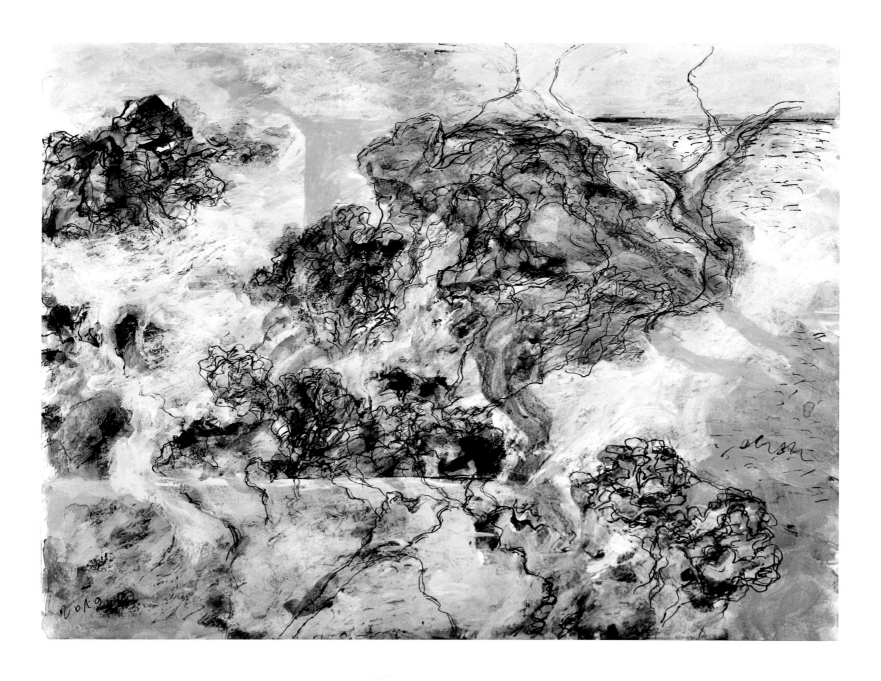

Through the Window
窗外遠眺
30 x 40 cm │ 2019

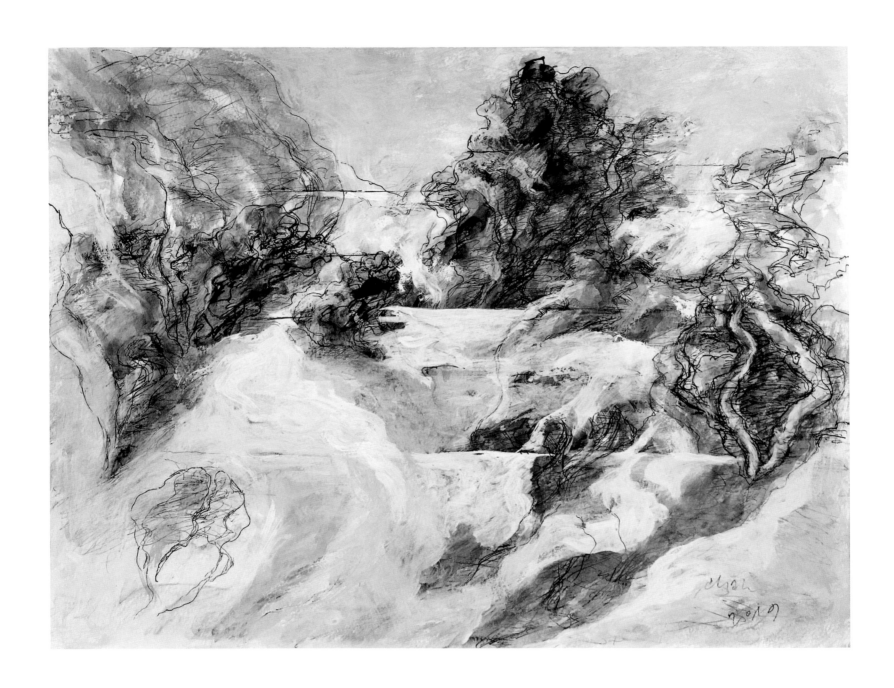

A Broken Heart
一顆破碎的心
30 x 40 cm | 2019

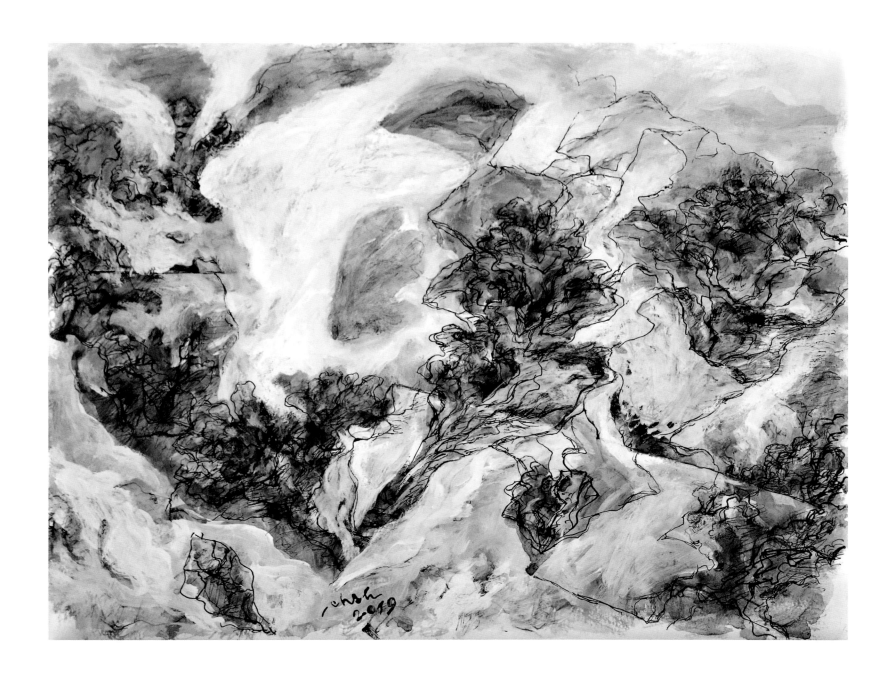

Neo-geometric Landscape
新幾何的風景
30 x 40 cm │ 2019

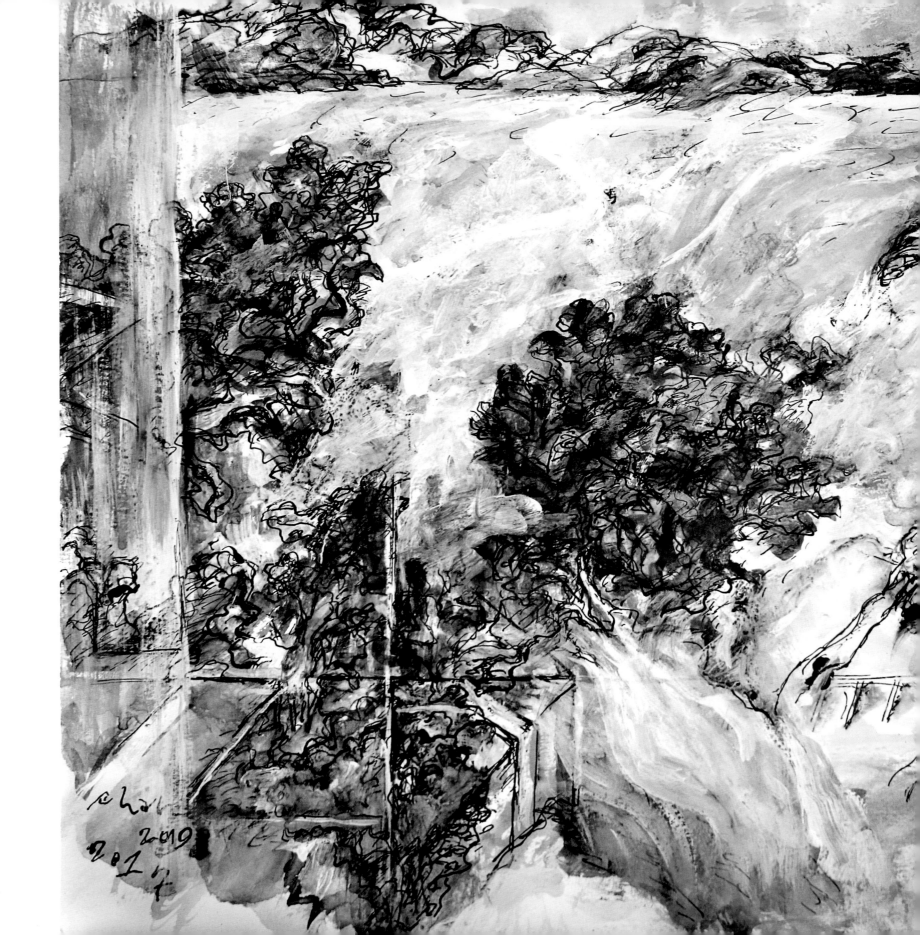

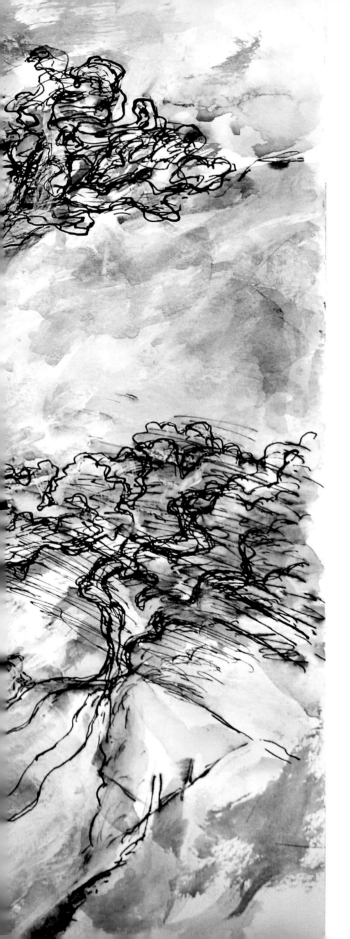

Out the Old Garden Window
故園窗外
32 x 41 cm │ 2017–19